IMAGES
of America

OVERTON PARK

IMAGES
of America

OVERTON PARK

William Bearden

ARCADIA
PUBLISHING

Published by Arcadia Publishing
Charleston, South Carolina

Printed in the United States of America

Library of Congress Catalog Card Number: 2004107282

For all general information contact Arcadia Publishing at:
Telephone 843-853-2070
Fax 843-853-0044
E-mail sales@arcadiapublishing.com
For customer service and orders:
Toll-Free 1-888-313-2665

Visit us on the Internet at www.arcadiapublishing.com

CONTENTS

ACKNOWLEDGMENTS

There are many people I wish to thank for their help in making this project become a reality. There are also many individuals who, over the course of my life, have been instrumental in more personal areas, encouraging and guiding me in my interests and pursuits. Chief among the latter group is my mother, Virginia Trigleth, who has been a loving, resourceful, open, and understanding parent and friend. Dudley Davis has been my friend and mentor since I was his student at Northwest Mississippi Junior College in the late 1960s. His unwavering support and constant encouragement have meant so much to me and have allowed me to achieve more than I ever thought possible. My wife, Cheryl, has made it possible for me to pursue my dreams. Her steady hand and loving heart are the very foundation of my personal and professional life.

John Linn Hopkins is a historian and friend who possesses a remarkable facility for understanding and telling the story of Memphis and the Mid-South. I have relied heavily on his paper, *Overton Park, The Evolution of a Park Space*, which was written in 1987 for Ritchie Smith Associates as part of their master plan for Overton Park. I have also used information from *Yesterday's Evergreen, Today's Mid Memphis*, by Bette B. Tilly and Pat Faudree for Memphis InterFaith Association (MIFA) in 1980. Countless newspaper articles, personal accounts, and my own exploration have rounded out the research for the book. All images, unless otherwise noted, are courtesy of the Memphis Room of the Memphis/Shelby County Library and Information Center, or Special Collections at the University of Memphis Libraries.

At different times over the past three years, Lori Finta, Bill Robison, and Savannah Bearden have worked with me in choosing, scanning, and laying out the images for this book. Their discerning taste and lack of hesitancy in challenging my assumptions have been indispensable.

My deepest gratitude goes to those people who have lived part of the story of Overton Park. Their willingness to give of their time, experiences, and opinions has been crucial to the telling of this story. John Hopkins, Laura Chandler, Sue Reid Williams, John Malmo, Wayne Boyer, Beverly Bond, Jane Hooker, Charlie Newman, Wayne Dowdy, Don Richardson, Kaywin Feldman, Scott Banbury, and Lissa Thompson were kind enough to participate in the on-camera interviews for the video documentary. Jim Johnson, Patricia LaPointe, and Joan Cannon of the Memphis/Shelby County Library and Information Service were of great help in finding photographs and newspaper clippings. Their knowledge of Memphis history was vital in this effort. Ed Frank and James Montague of Special Collections at the University of Memphis were especially helpful in finding the many obscure and interesting photographs that help to reveal this story. I would also like to express my thanks to the following group of individuals who helped in many ways to push this project along: they are, in no particular order, Hal Harmon, Jay Martin, Bob Riseling, Rafe Murray, Bennett Wood, Pam Parker, Blaine Baggett, Murray Riss, Mike Bass, George Larrimore, Debbie Walker, Gaines Bearden, Jeff Bearden, Eugene Trigleth, Bob McCrary, Steven Ross, Tabitha Finta, Adam Hawk, Chuck Porter, Ray Skinner, Bill Bullock, Jim and Taryn Spake, Clark Secoy, Ray M. Allen, Scott Blake, the Board of Park Friends, Inc., Glenn Cox, Melanie White, Tony Becker, David Kessler, Fred Hoffer, Carol Ann Mallory, Eric Miller, Bill Rehberg, Wain Rubenstein, Gray Clawson, Stacey Greenberg, Michelle Bird, Jeff Nesin, Chris Carruthers, Bob Brame, Dr. Richard Ranta, Bert Sharpe, Thomas Melton, Betty Spence, Barry Burns, Eric and Cheryl Patrick, David Acklin, Brenda Wood, Kathy Randle, Jennifer Coleman, Carrie Strehlau, Cary Holliday, Dan Hope, Marsha Oates, Wayne Risher, Larry Keenan , John Larkin, Sheila Burns, Kate Dixon, Edward Hawkins, Rollin Riggs, Tom Bailey Jr., Shelby Foote, F.P. Dugan, Helen Witte, Gene Brogdon, Pat Brooks, Russ Abernathy, Teri Sullivan, Ray Skinner, Howard and Baylor Stovall, Pat Mitchell, Sid Selvidge, and my computer guru, Wiley Brown.

Had it not been for the many photographers, both known and unknown, who took the time to document these places and people throughout the last 100 years, this book would never have come into being. I offer my deep gratitude and thanks to all who recognize the importance of preserving our common story.

And finally, I am grateful to my children, Savannah, Matt, and Maggie, for taking the time to walk with me.

William Bearden
June 2004

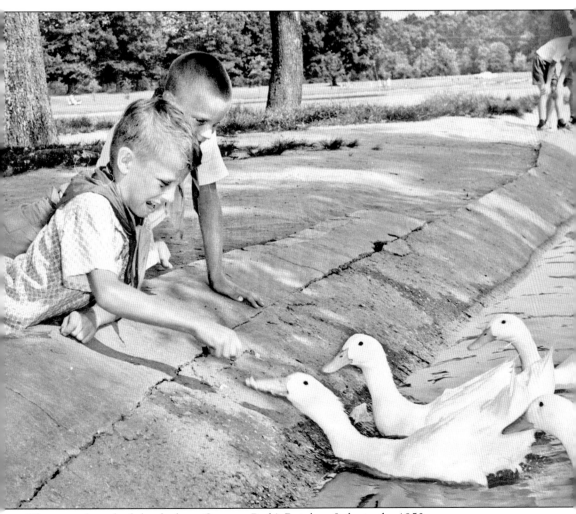

These two boys feed the ducks at Overton Park's Rainbow Lake in the 1950s.

INTRODUCTION

Standing in Overton Park's Old Forest on an early morning, it is easy to imagine a time 100 years ago when much of the country surrounding Memphis was covered in hardwoods, muscadine vines, saplings, and underbrush. It is said that just 200 years ago the forest was so dense and seemingly unending that a squirrel could travel from the Mississippi River to the Atlantic Ocean without ever touching the ground—a sobering thought, indeed, especially as nature falls endlessly victim to modern development. But even with all the changes brought about by the settlement of Memphis and the Mid-South, the Old Forest still stands. It stands as a testament to the dreams of the city builders, those progressive men and women who, 100 years ago, strove to bring Memphis back from a disastrous past and into the 20th century. It also stands as a touchstone of our common rural past. After all, most Memphians are from "somewhere else"—the Mississippi Delta, rural Tennessee, or eastern Arkansas—refugees from small towns that offered little in the way of making a living, making it big, or simply making a fresh start. The Old Forest reminds us of that past.

For almost 25 years, I have lived in the neighborhood just west of Overton Park. It is a classic Memphis neighborhood. Bungalows and four-square houses line the quiet streets, all under the canopy of tall oak and elm trees. It is a good neighborhood; I can see myself living here until I am an old man. In the early 1980s, I spent countless hours walking with my young daughter, wandering the vacant lots known as "the corridor," those blocks where the houses had been torn down in preparation for the construction of Interstate 40. That construction would have also slashed through Overton Park, doing irreparable damage to the old growth forest that, luckily, still thrives there. On those frequent walks, I would note the newly blooming dogwood tree, or the border of daffodils, or the bed of tulips, all forgotten on now empty lots. One day my daughter, who must have been four or five, asked me why there were "sidewalks to nowhere." As I fumbled with an explanation of how some people had thought it was a good idea to put an expressway through the park and through this neighborhood, I felt the full impact of the absurd devastation around me. I thought of the many people who had lived their lives in these houses, raising families and living through hot summers, Easter egg hunts, and beautiful fall evenings. All are gone now. And I wondered if they sometimes drove by slowly on a Sunday afternoon, telling the fidgety kids in the backseat of past times and family lore, remembering the treehouse, or the girl who lived down the street, or the sound of metal-wheeled roller skates on the sidewalk. Or maybe they just drove by silently, believing they were better off now in another house. But I'd like to think that the weighty pull of home made them stop for a moment and think of another time, bad or good, when this was home.

Thanks to a Supreme Court ruling, the I-40 project was abandoned more than 20 years ago, and the corridor is again filled with families and beautiful homes. But I often go back to that question my daughter asked. I wonder what would have happened if the expressway *had* gone through the park and through this neighborhood, with thousands of cars and trailer trucks roaring non-stop through the heart of the city at every hour of the day and night. I'm glad we don't have to live that reality. I'm thankful for the people who stood up for the park and for the neighborhood. These years later, I am deeply grateful each time I walk through the "corridor" with friends or family. This book is a way of expressing that thanks. In a way, I have been working on this project since that day in 1983 or 1984. I have watched as the neighborhood struggled; the politicians and movers and shakers put forth plan after plan; the newspapers editorialized; and citizens, for and against the expressway, wrote letters to the editor and called in on talk radio shows, weighing in on the eternal question. Even now, it seems that every week or so some individual writes a letter to the *Commercial Appeal* bemoaning the fact that the

expressway wasn't built through the park. It is a controversy that will likely never die.

I don't know what total effect the expressway would have had on the park, but I can't imagine my life and the lives of my children without the park in its present state. My children took some of their first steps of freedom and social individuality on the park playground, looking back at me as they climbed a little higher, or crawled up the slippery part of the sliding board, or swung on the tire swing until they were dizzy with delight. My son can name many of the trees there. He knows when the pawpaws are likely to be ripe and where to find lizards and toads. We have also established traditions that are tied to the park. Every Thanksgiving morning we take a walk, and I photograph my three children against the brilliant backdrop of autumn foliage in the old forest. We use this as our Christmas card photo for friends near and far. These Thanksgiving Day walks have become so significant that our extended family of friends and relatives has begun to come along and share the experience. These outings add to the sweetness of life and bind us even closer to the park. My daughter, that child I wrote about earlier, is now 23 years old and has helped with the layout and writing of this book. This is a symmetry I recognize and appreciate.

It occurs to me that Overton Park is a reflection of Memphis, a portrait in miniature of the beauty, problems, diversity, and complexity of the city itself. Just as Memphis is a collective of the people and lifestyles and attitudes of Frayser, Whitehaven, East Memphis, Midtown, North Memphis, and every other neighborhood, so is the park a collection of separate entities, each with its own style and agenda. The park is no one thing; instead, it is the ethereal manifestation of both the synergy and the friction among the Old Forest, the Shell, the Parkview, the Zoo, Memphis College of Art, the golf course, the Doughboy, and the substantial weight of its own historic past. I find that the people of Memphis have strong opinions about the park. No one is ambivalent about what has happened, what is happening, and what should happen to those 342 acres. Just as I think I have heard every opinion, someone comes along with something new: move the zoo, enlarge the golf course, clear the brush out of the woods, tear down the shell, build more war memorials, open the roads through the woods, close all the parking lots, and on and on. These diverse opinions merely point to the fact that as Memphians, we have a profound sense of ownership when it comes to Overton Park.

This book and a video documentary grew out of another walk I took, this one on Earth Day 2000. A group of 20 or so of us gathered at the entrance to the old forest with our guide, Don Richardson of the Sierra Club. Among us were women, men, old, young, black, white, Hispanic—a true cross section of what Memphis is today. As we walked through the forest, we saw the manifestation of the work these volunteers had accomplished in maintaining the trails, marking the unique features of the forest, mapping and cataloging each tree. These volunteers have come to the realization of just how precious and yet volatile the forest truly is, and their dedication became a primary inspiration for this book. Through the efforts of these "true believers," the old forest will remain a sanctuary.

During the last century, the role of parks has changed dramatically. It is no longer the community's backyard or front porch as it was in the early part of the century. We now have air-conditioning and television, which lure people inside on summer evenings. So many entertainment choices compete for our time and money that we no longer need outdoor operas, musicals, and stage plays. Instead of summer park commission programs, we now have Little League baseball, summer basketball, church league baseball, and endless other planned activities for children. Clearly, as a people we have changed. Our needs are no longer the needs of that generation of our forebears who marveled at the great open spaces and the strange and wonderful amenities of our first great park. Yet we are still tied to the land, and Overton Park is where we can touch that primeval part of our past and relive it.

In its first 100 years, Overton Park has seen periods of progressivism and growth, depression, wars, bitter public arguments, neglect, and rebirth: those very human characteristics that have earned it a special, almost sacred place in our hearts. My hope is that the next 100 years will be as dynamic and as meaningful as the first.

In the fall of 1898 a bill was prepared by Mayor Williams authorizing the City of Memphis to issue bonds for the purchase and condemnation of lands for parks and parkways and the election of a board of park commissioners. This act was passed in 1899. On July 5, 1900, an ordinance passed providing for parks and the appointment of a park commission.

—John Linn Hopkins

One

THE EARLY YEARS

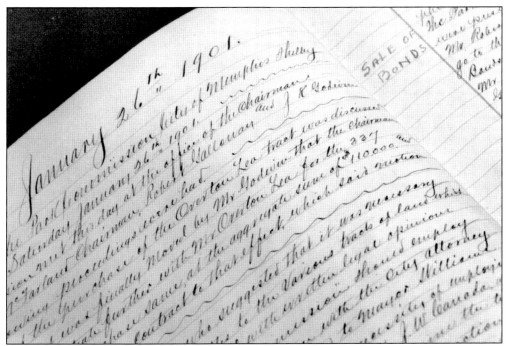

This image is of the original minutes of the newly formed Memphis Park Commission. The meeting was held on January 26, 1901, and proposed the purchase of the tract of woods known as Lea's Woods.

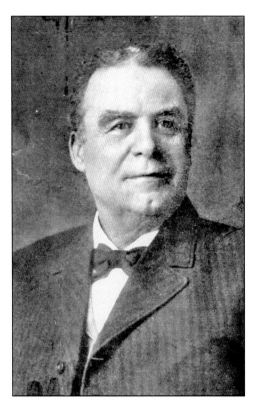

Wealthy Memphian and original park commission member Robert Galloway lived near the park in Glen Mary, later to be known simply as the Galloway Mansion at Overton Park and McLean. Colonel Galloway traveled the world, a pursuit that had a great influence on his thinking about public spaces and especially Overton Park. Galloway's influence on the design and amenities in the park can still be felt today.

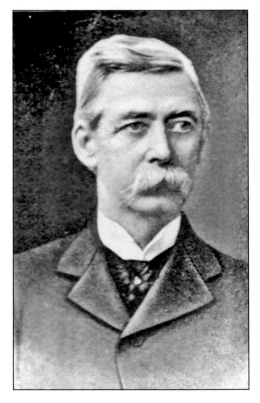

Judge Louis B. McFarland was one of the earliest proponents of municipal park development in Memphis. Although McFarland was mostly focused on redeveloping a riverfront promenade and development of an old railroad site at Court and Marshall, his ideas, coupled with George Kessler's proposed annexation of the area within the Parkways, jelled the progressive agenda for park development. McFarland was chosen as chair for the first convening of the newly established Memphis Park Commission in 1900. McFarland is quoted as saying, "I am a great believer in the aesthetic as applied to cities. I consider it as an important element as in private residence, and even more so. The city that is attractive in appearance has the advantage over the city that is not."

Born in Germany in 1862, George Edward Kessler was a rising star in the relatively new field of landscape architecture at the turn of the century. His selection over better-known Frederick Law Olmsted as designer of Overton Park was a high point in his early career. In 1901, he was employed by the Memphis Park Commission to design Overton and Riverside Parks, as well as the Parkway system. Kessler died in 1923.

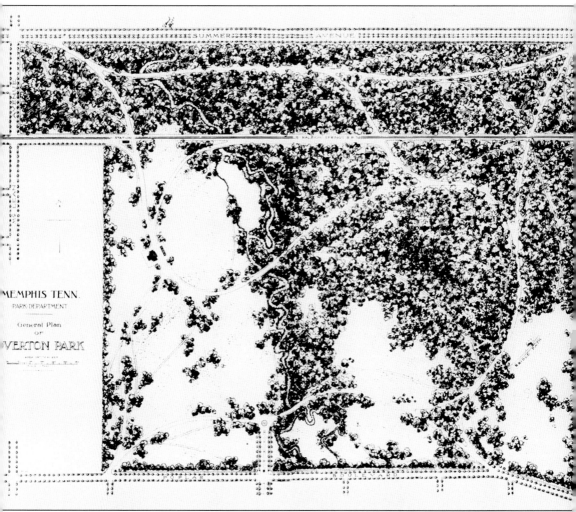

This general plan for Overton Park was developed by George Kessler. The park was to incorporate wide-open spaces for community activities, games, and gatherings. These 342 acres were purchased from Overton Lea of Nashville, an ancestor of one of the original founders of Memphis. The forest, which was recognized even then as a unique feature, was to be left alone except for the limited roads and carriage paths winding through its grandeur. It is the foresight of these early pioneers that has kept the forest distinctive as one of the only untouched wooded areas in the world that is in the middle of an urban setting.

George Kessler is quoted as saying, "In Overton Park you have saved the other chief characteristics of this region by preserving in the forest conditions of the virgin forest upon that property. Nowhere in the United States, except in the Pacific Northwest, will you find tree growth as luxuriant as in the Western Tennessee and Eastern Arkansas forests, and in the two hundred acres of virgin forest in Overton Park you have a property which, as a heritage to the public for the enjoyment of nature, equals in value the cost of the entire park system to the present time."

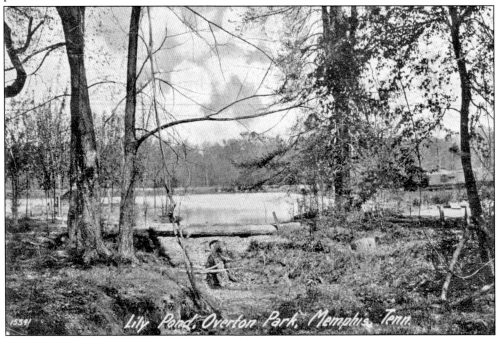

15

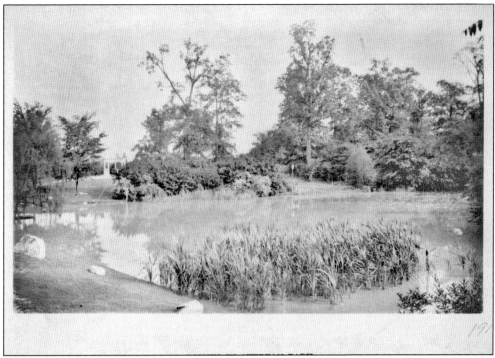

This reed-filled pond is one of many that have come and gone in Overton Park over the last 100 years. Although slow and nearly imperceptible, changes to the park continue even today.

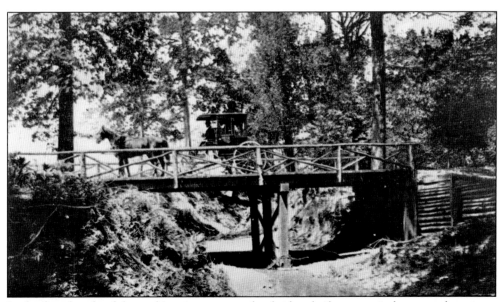

In the first decade of the park's existence, wooden bridges built to sustain horses and carriages criss-crossed streams throughout the woods. By 1920, all of these rustic bridges had to be replaced by stone bridges because of the recent influx of automobiles as the primary mode of transportation throughout the park.

One of the earliest-known photographs of the park, this c. 1903 image shows a manicured but untamed land in the center of Memphis. While the park was slow to develop at first, by 1905, it would explode into an extremely popular recreation destination for Memphians and visitors.

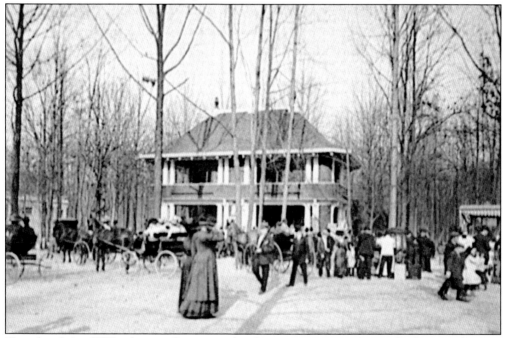

Completed in 1902, the pavilion was the first structure in the park. It soon became acknowledged as the center of all Overton Park activity, hosting countless dances, concerts, and civic gatherings. In 1936, the pavilion was severely damaged by a storm and cost of restoration proved too steep for the park commission. It was demolished in 1939.

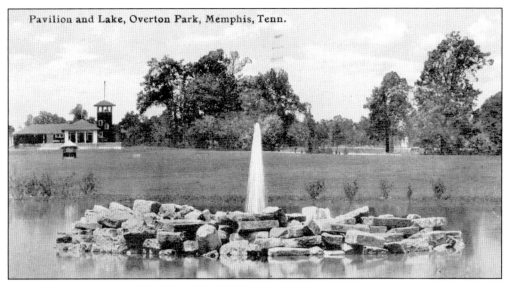

Pavilion and Lake, Overton Park, Memphis, Tenn.

Originally dubbed "East End Park" or simply "East Park," the park was renamed "Overton Park" to honor the Overton family, and particularly John Overton, for their contributions to the history and development of the city of Memphis. The change in name ended the confusion of Overton Park with East End Park, a privately owned amusement park located near the intersection of Madison Avenue and Tucker Street.

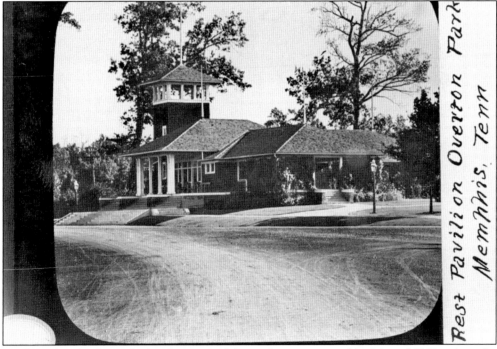

Rest Pavilion Overton Park Memphis, Tenn

Kessler's plan for the early development of the park was approved by May of 1902, when the commissioners voted to expend $7,500 for "improvements to East End Park," not to include the cost of the roadways and related elements. The main pavilion was built from this fund and was completed in August of 1902. The drives, bridges, and sodding were mainly completed by the end of the same year.

Even though Kessler's original plan for the park did not include a golf course, it did provide ample open spaces for its construction. The first mention of an interest in a course occurred in the park commissioner's minutes of March 9, 1904, whereupon the motion of Judge L.B. McFarland, the commissioners moved to establish a "golf links." The only other golf course in the city at that time existed at the Memphis Country Club.

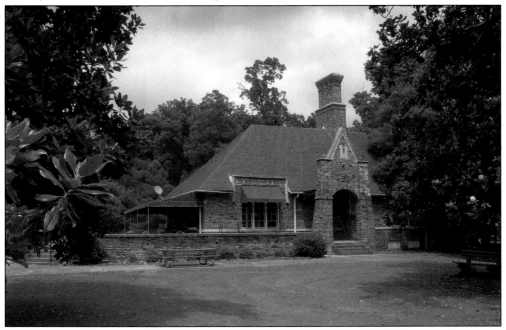

Part of the golf course includes the club house, which dates from 1926, the gift of park commissioner Abe Goodman. The English Tudor Revival cottage replaced an earlier structure from c. 1912–1913, which, in turn, was developed from the old cast-iron bandstand that once stood on the site of the Memphis Brooks Museum of Art.

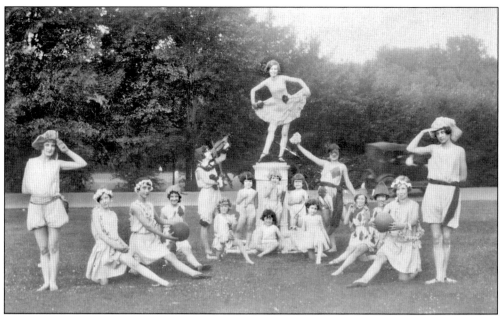

By the 1920s and 1930s, Overton Park had truly established itself as Memphis's backyard. The Memphis Park Commission helped this establishment by running youth programs in the park, sparking scenes such as this one where young children and teens put on fanciful performances during the summer months. Thousands of Memphis youth participated in these pageants.

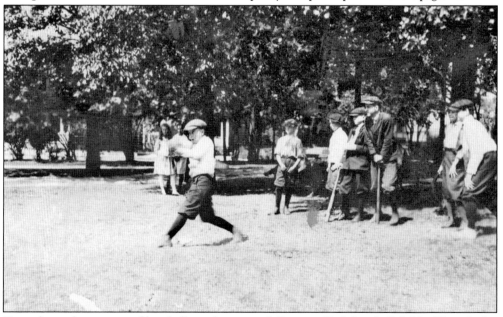

Young boys play a game of baseball on the original Overton Park baseball fields. Though the area east of the Doughboy monument has probably been used as a playing field since the first days of the park's existence, the playing fields were not formalized until around 1907. Early photographs show the layout of a single baseball diamond in this area. While the intensity of use and the general arrangement of these fields have changed over the years, the fields remain in heavy use today.

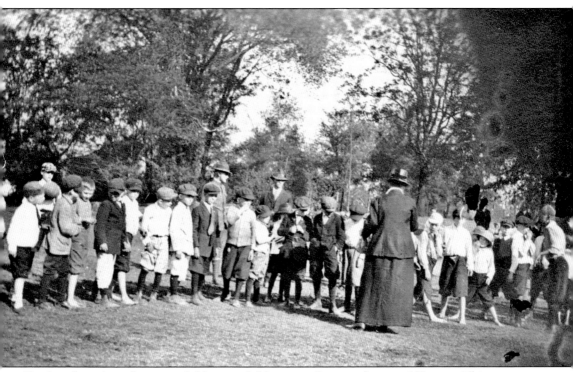

Teachers have been bringing children on field trips to Overton for over 100 years. This group could possibly have been from Snowden School, built in 1910 just across North Parkway from the park.

In 1902, Memphis businessman A.B. Carruthers received a bear as payment for a wholesale order of shoes from a Natchez, Mississippi retailer. Carruthers, in turn, gave the bear to the Memphis Turtles baseball team who adopted "Natch" as their mascot. After getting too frisky with the players and fans, Natch was given back to Carruthers, and tied to a tree in front of his home at the corner of Evergreen and Galloway. The situation again deteriorated as Natch dug up Mrs. Carruther's pretty flower beds. Natch was then tied to a tree in Overton Park, and quickly became a major attraction. From these humble beginnings, a great zoo arose.

—William Bearden

Two

THE ZOO

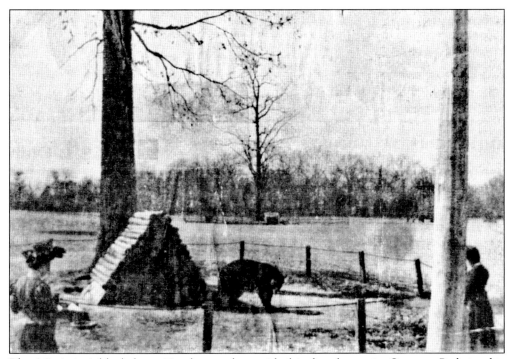

The Mississippi black bear, Natch, stands outside his first home in Overton Park in this *c.* 1903 photograph.

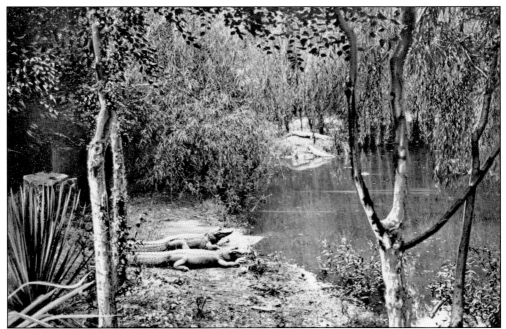

The Memphis Zoo Association was organized by Robert Galloway in 1906. Along with Natch, donations of a camel by Pawnee Bill, a tiger by Ringling Brothers Circus, and an elephant as a gift from the Memphis Lumbermen began the practice of civic groups and individuals giving animals to the zoo. Alligator Lake was filled with a former Mississippi Delta resident in this 1913 photograph.

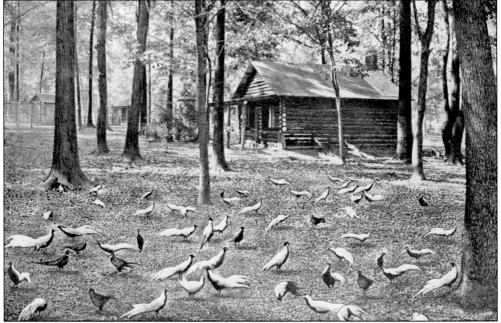

Pheasant forest set the tone for strolling through the zoo grounds in 1914. The site of the zoo was selected by Kessler and was approved for development in the northwestern corner of the park, just north of the Memphis Street Railway right-of-way.

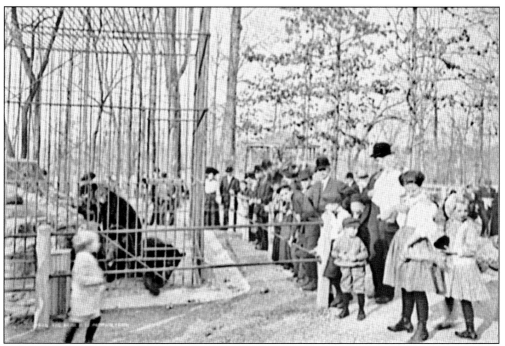

The bear pits were some of the first cages built with the $1,200 granted by the park commission in 1906.

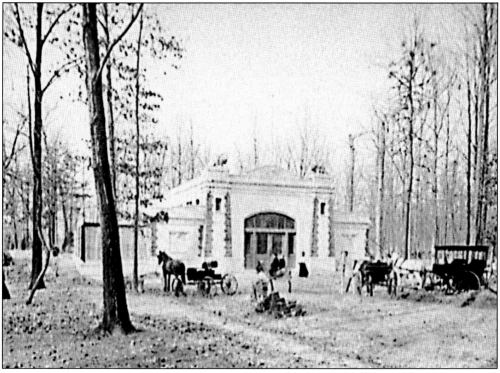

One of the first permanent structures at the zoo was the Carnivore House. This structure still stands, today housing the gift shop and restaurant.

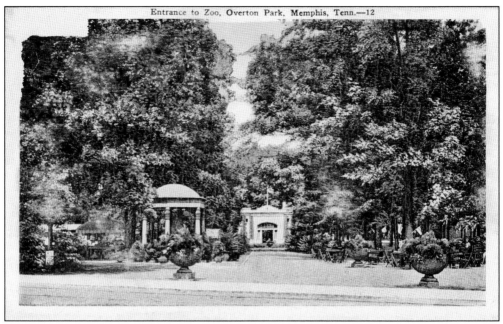

Entrance to Zoo, Overton Park, Memphis, Tenn.—12

These two postcards show the next phase in the development of the zoo. Landscaping and water features became important as the entrance and walking paths became more defined.

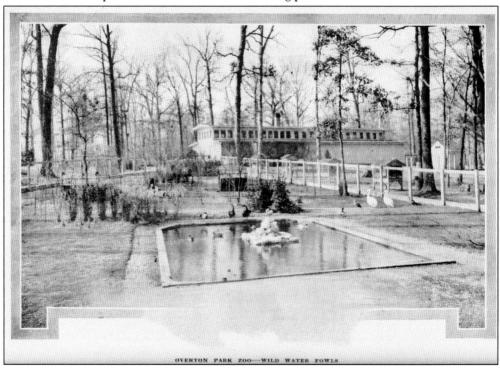

OVERTON PARK ZOO—WILD WATER FOWLS

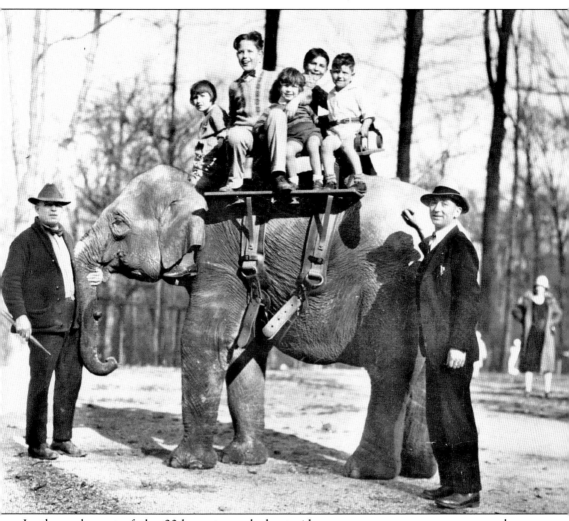

In the early part of the 20th century, elephant rides were a common occurrence and a popular attraction in zoos across America. The aggressive growth of the zoo brought a great deal of national recognition, ranking it second among the nation's free zoological institutions. Unfortunately, the flush of success brought a long period of public apathy, resulting in the deterioration of the facility and jeopardizing the health of the animal population. The winter of 1922 saw a renewal of interest in the Zoological Society, which re-emerged in a reorganized form on February 6, 1923. The state of the zoo facilities began to improve rapidly soon thereafter.

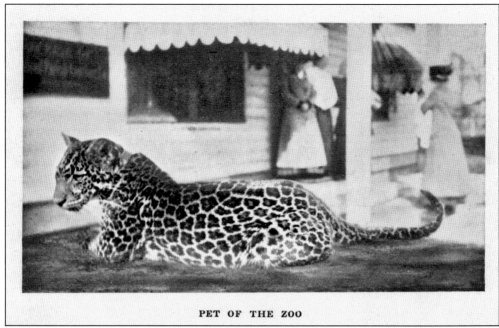

PET OF THE ZOO

Attitudes about animals and their proximity to humans have certainly changed in the 100 years since the zoo was developed. A jaguar (above) lounges in the shade as visitors stroll by. Two little girls on a park bench (below) pet the newest additions to the zoo's lion family.

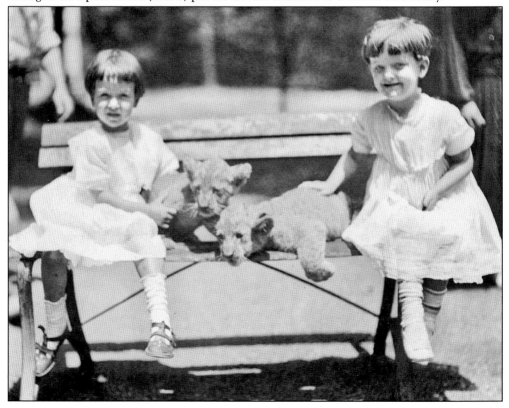

This 1918 photograph shows the newly built hippo house. For many years, the Memphis Zoo was recognized as having the most successful hippopotamus breeding program in the world. This is attributed to Adonis, a male hippo, and his mate. Adonis set another record upon his death: the longest living hippo in captivity (56 years).

An early motorcycle is parked in front of the Carnivore House in this image from 1919. More traffic meant the need for more parking spaces for popular attractions such as the zoo. Today, on busy spring and fall weekends, the park is packed with automobiles and buses.

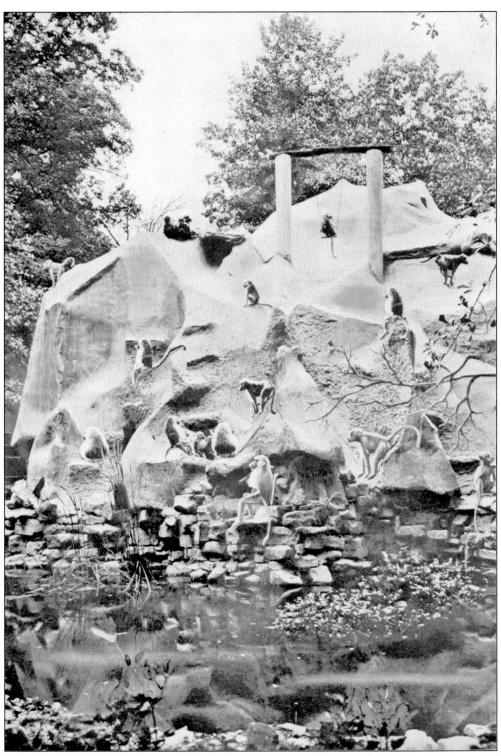

Monkey Mountain was the big draw to the Memphis Zoo in 1913. This concrete "mountain" was thought to portray a more realistic home for its inhabitants than a mere cage.

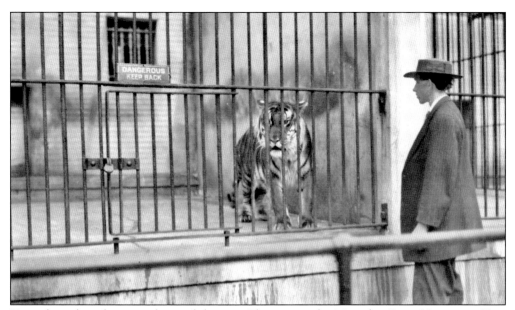

Tigers have long been residents of the zoo. The mascot for Memphis State University, Tom made his home at the zoo for many years before moving into private quarters in the 1990s.

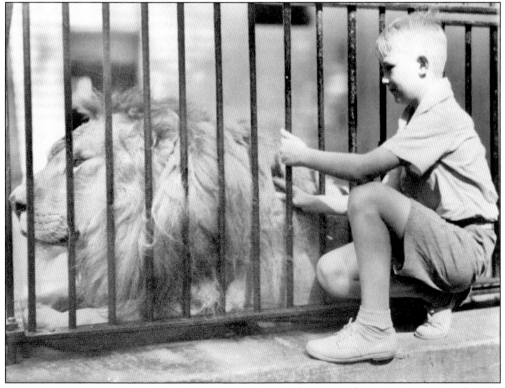

The famous MGM lion was born and died in the Memphis Zoo. This youngster is too close for comfort in this photo from the 1930s.

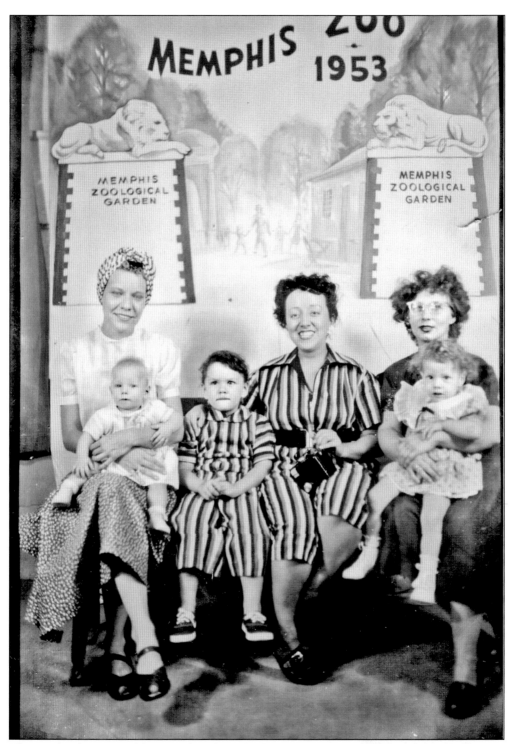

Thousands of pictures of families, friends, and relatives were taken in front of this familiar zoo backdrop. Norma Ware (far right) holds daughter Jackie in this 1953 photograph. (Courtesy of Jackie Ware.)

Throughout the 1950s, the zoo was still a popular destination, but by the late 1960s, amid the Interstate 40 controversy, attendance had dropped substantially.

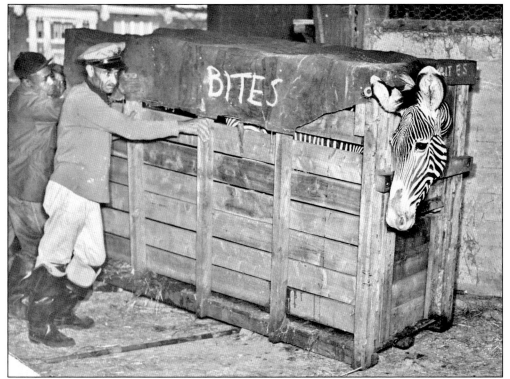

It appears this zookeeper is heeding the advice painted on this zebra's shipping crate.

Beginning in 1938, the circus at the zoo drew large and enthusiastic crowds. Performances were staged throughout the day. By the 1970s, the circus was discontinued for being too costly.

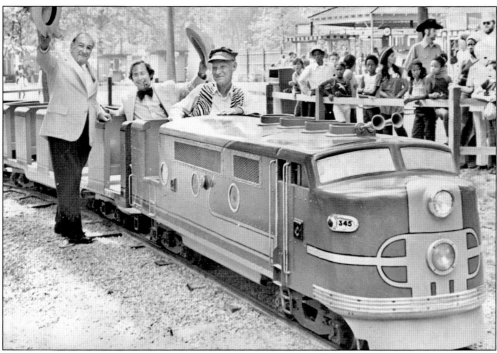

The sound of its familiar steam whistle echoing through the park, the train ride continues to delight children and adults alike.

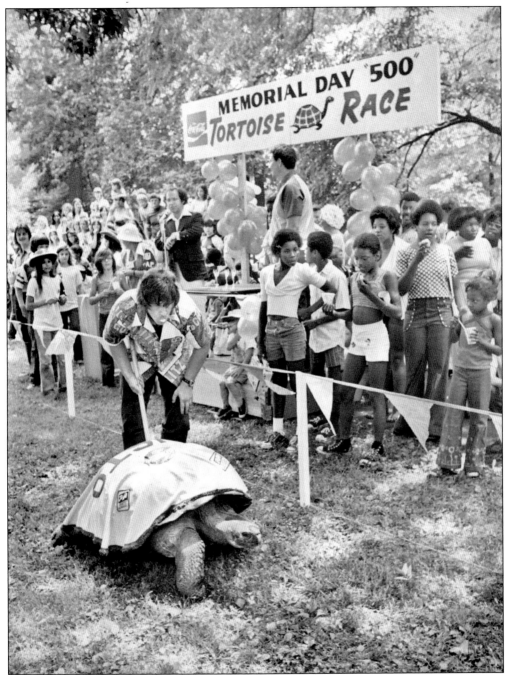

Memorial Day festivities and this tortoise race drew hundreds of Memphis children to the zoo in May 1980. It is not reported who won the race.

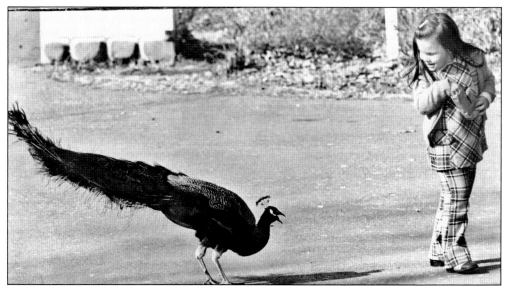

This little girl is not so sure about the intentions of the peacock she is feeding. Since its inception in 1904, the Memphis Zoo has always had a large and diverse delegation of birds roaming the grounds.

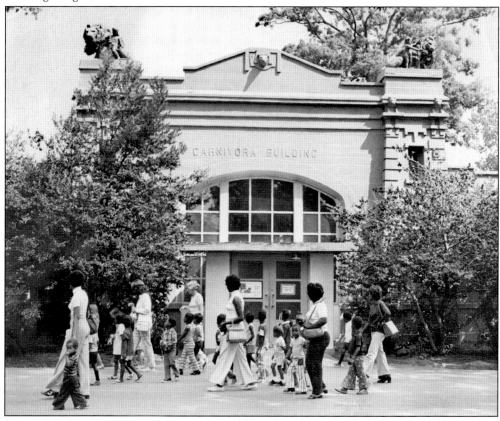

Originally allowed access to the zoo only on Thursday afternoons, by the early 1960s, African Americans had finally achieved the right to visit the park and the zoo without restriction.

Although partially hidden behind the balloons, the regal marble lions at the main gate to the zoo were carved in Italy about 1900. They were given to the zoo by the Van Vleet family in 1936.

Overton Park was a place of magic for me . . . the fountain with waters that danced and changed colors, and the romantic music of the operettes at the MOAT under the stars. Dances, picnics, all were a part of the summer magic that brought so many Memphians together, so many ages, but who could all laugh together.
—Sue Reed Williams

Three

REFLECTIONS
of MEMPHIS

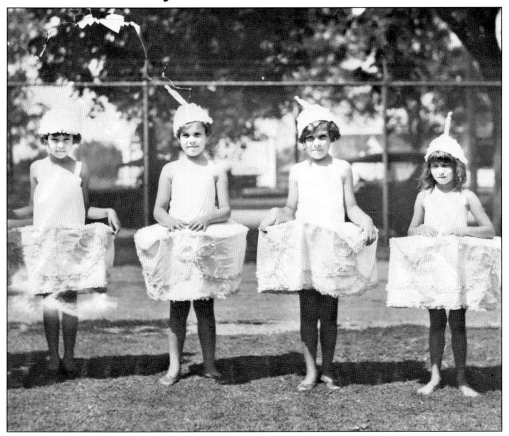

This *c.* 1940 photograph was part of the archives of the Memphis Park Commission, which was presented to the Memphis Room of the Memphis/Shelby County Public Library and Information Center in 2001 for research and preservation. Sadly, none of the children are identified.

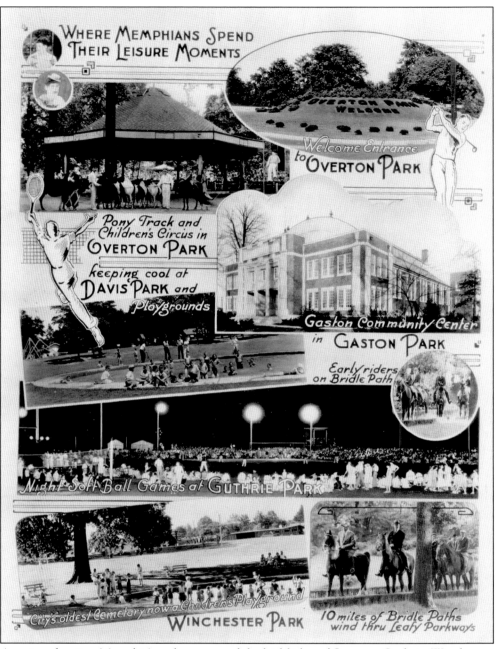

A poster advertises Memphis's park system and the highlights of Overton, Guthrie, Winchester, Gaston, and Davis Parks.

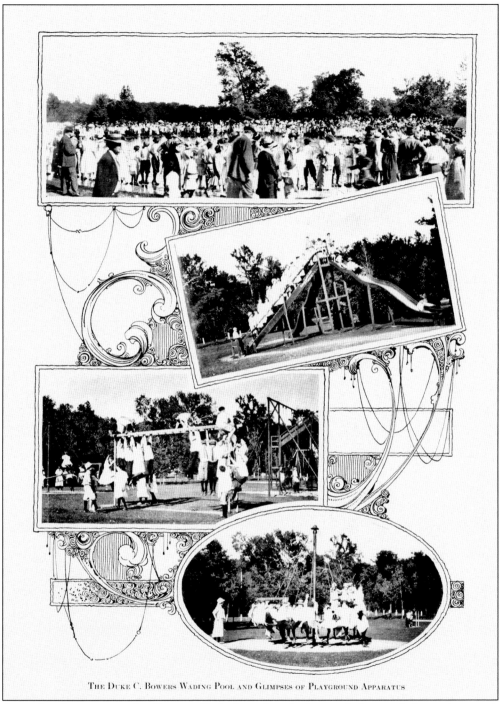

THE DUKE C. BOWERS WADING POOL AND GLIMPSES OF PLAYGROUND APPARATUS

An early advertisement for Overton Park shows hundreds crowded around the wading pool, lines at the sliding board, and dozens of revelers on the monkey bars and giant swing.

These early photographs show the park in 1912. The future site of Rainbow Lake can be seen against the trees in this photo of the playing fields (above). The golf course (below) bears little resemblance to today's manicured links.

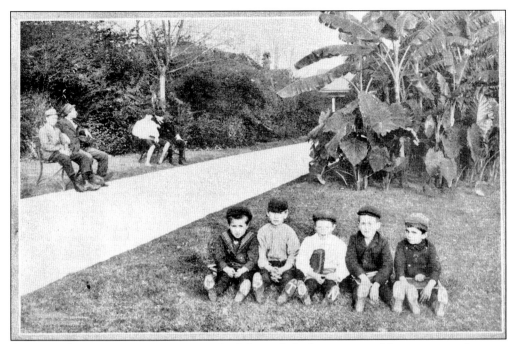

A group of youngsters poses against a backdrop of elephant ears and banana trees along an Overton Park sidewalk.

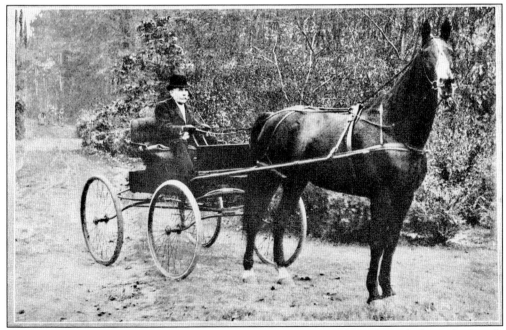

A horse and buggy were the perfect means for taking a relaxing drive through the park. A walk through the forest today reveals the remains of small bridges along the carriage paths that wound their way throughout the woods. Horses could be rented at what is now the Fairgrounds.

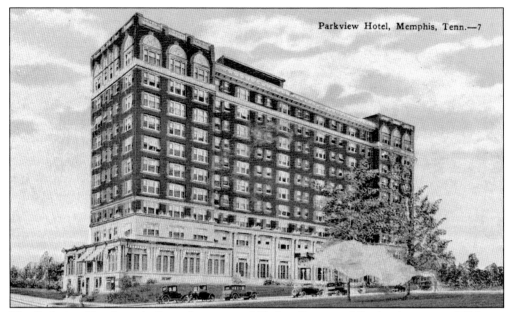

The Parkview Hotel was built at the corner of Tucker Street and Poplar Avenue in 1926 as a residence hotel. An amusement park called Fairyland had occupied the site from 1906 to 1909, when it burned. The hotel proprietors undoubtedly hoped that many of the visitors to the park would stay at the hotel. Since the 1970s, the Parkview has served as a retirement community.

THE LOBBY

This boy has just won a sack race or a swimming competition and proudly wears a ribbon on his chest. The open spaces and pavilions of Overton Park were quickly adopted by the community for outdoor gatherings and special events, such as pageants and parades centering on political and social occasions. The park also became the site of athletic competitions and tournaments, both local and regional. The culmination of summer activities was the Playground Festival in Overton Park, which included field events and theatrical performances. Children representing the city's different playgrounds and community centers came to Overton to demonstrate their athletic skills and artistic talents.

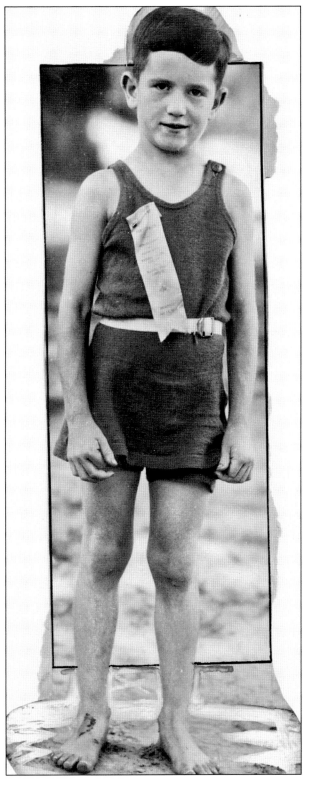

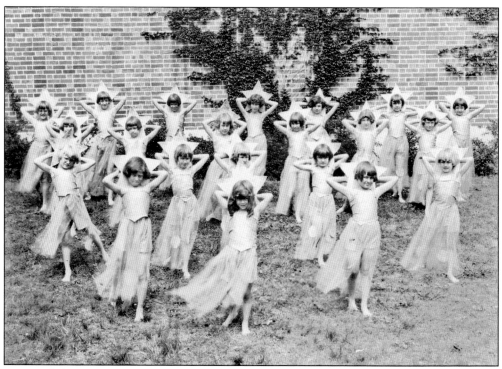

A sea of dancing children (above) and a circle of day campers (below) spend another memorable day in the park as part of the Memphis Park Commission recreation department summer program.

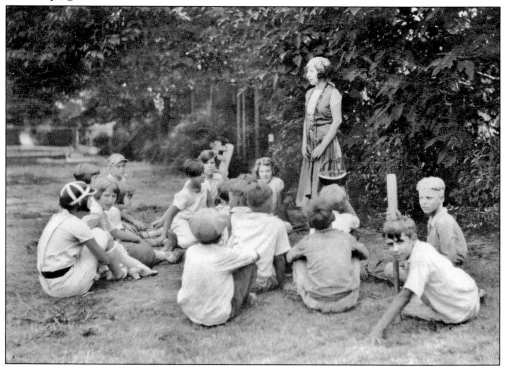

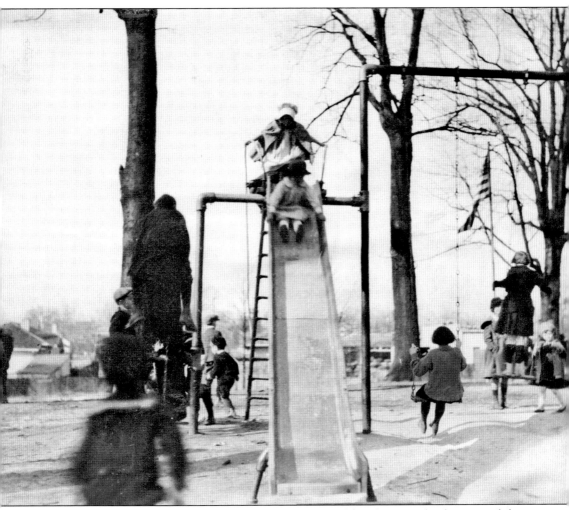

The playground was installed in 1911 as Memphis's first public playground. The giant slide tested the bravery of many Memphis children.

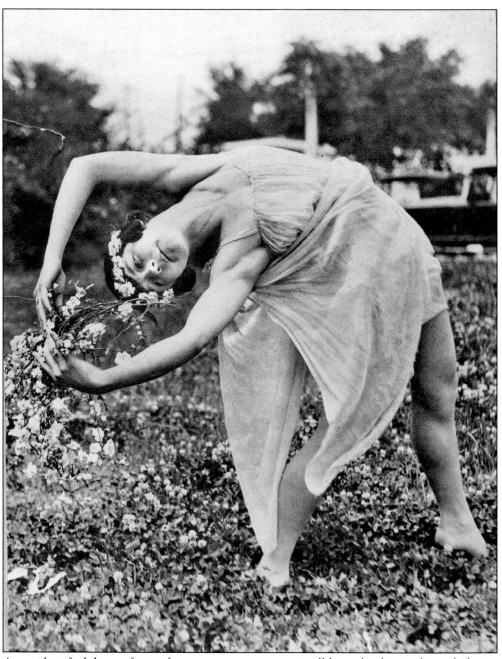

An unidentified dancer from a forgotten pageant poses, in all her splendor, in the park during the 1920s.

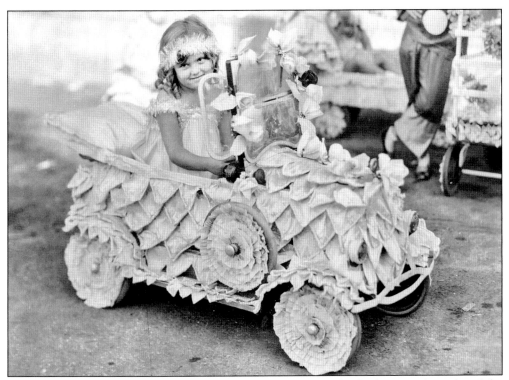

Elaborate costumes, handmade floats, and beautifully decorated vehicles were the order of the day in these two photographs from park commission pageants from the 1920s.

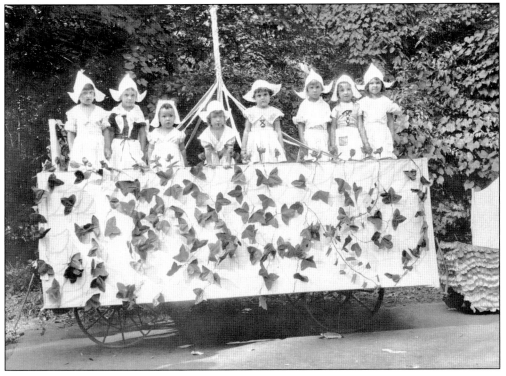

Costumed characters from elaborately staged productions pose for a photograph on the playing fields of the park.

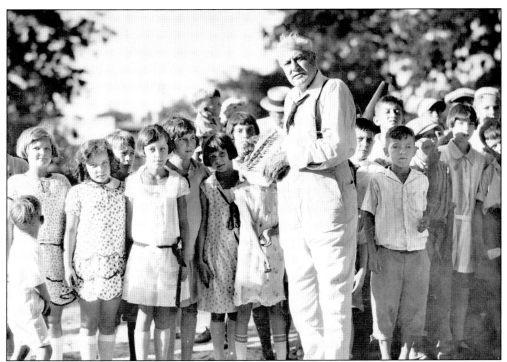

Children crowd around someone identified simply as the "candyman" in this 1920s photograph.

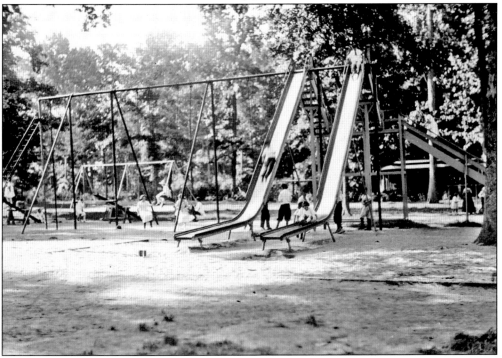

This playground was located on the western edge of the park, along Kenilworth Street. The playgrounds at Overton Park were the first in the city. Although antiquated by our modern standards, they were thrilling to the children of the early 20th century.

A community litter clean-up effort is pictured here, with children pitching in to keep the park clean. During the 1940s, 1950s, and 1960s, Memphis was known as one of the cleanest cities in the country.

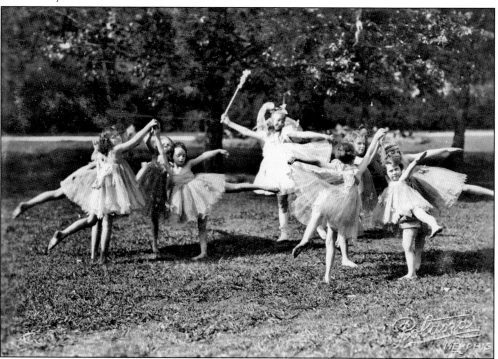

Dancing fairies rehearse in preparation for a performance at Rainbow Lake.

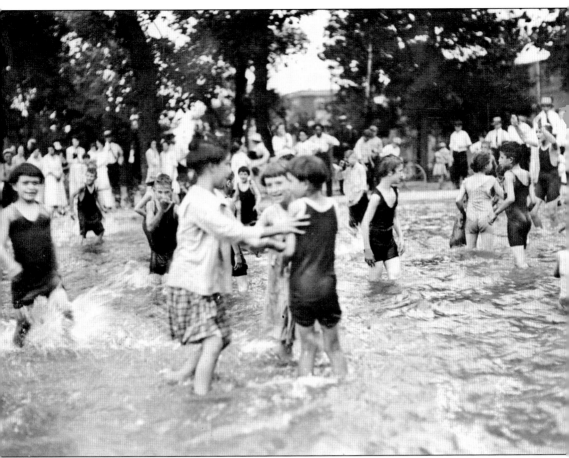

Named for its donor, a wealthy Memphis grocer, the Duke C. Bowers wading pool was a gift to the city in 1914. It was installed as a complement to the playground and remained a welcome part of hot summer days for Memphis children until falling into disrepair in the 1970s. The pool was covered over during the expansion of the park's playground around 1979.

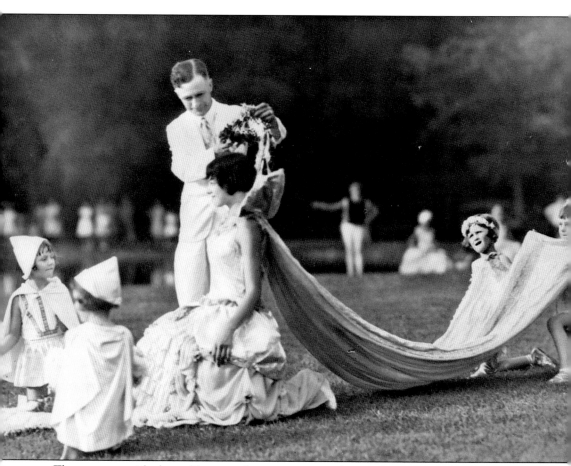

The queen, with her able attendants, is crowned in a ceremony in Overton Park. Its central location, generous playfields, shaded picnic grounds, and scenic pathways have made it a favorite place, one that many lives have crossed. The lack of identification of people, places, dates, and events from the Park Commission archives leaves only speculation these many years later.

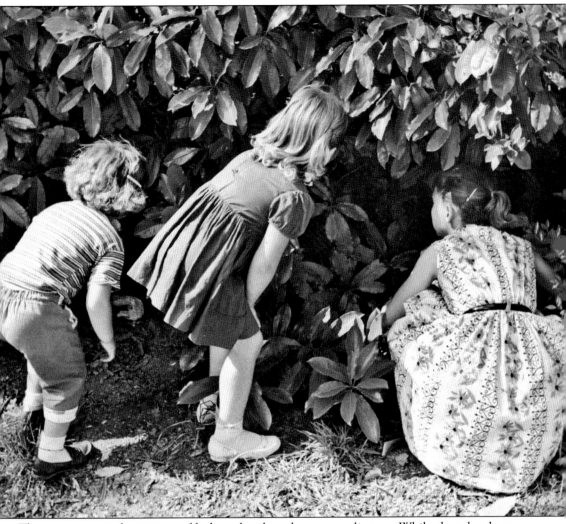

These youngsters play a game of hide and seek under a magnolia tree. While there has been an ongoing evolution in the park's built form in response to the changing needs and demands of facilities and to varying interests and customs of society, the basic configuration of the underlying landscape has remained the same.

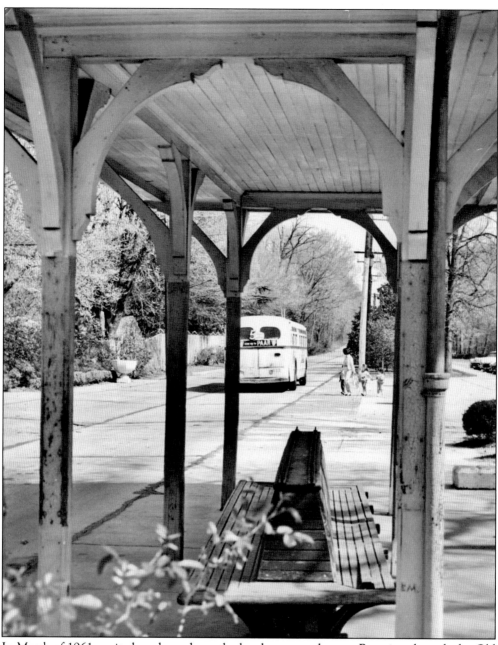

In March of 1961, a city bus chugs down the bus lane near the zoo. Running through the Old Forest from East Parkway to McLean, this was later the proposed route for Interstate 40.

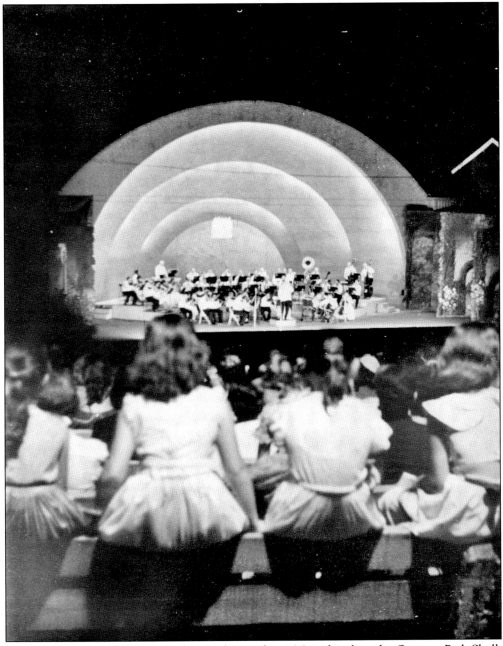

On summer nights, there was no better place to be in Memphis than the Overton Park Shell. Countless musicals, concerts, and dramas have graced the stage for almost 70 years.

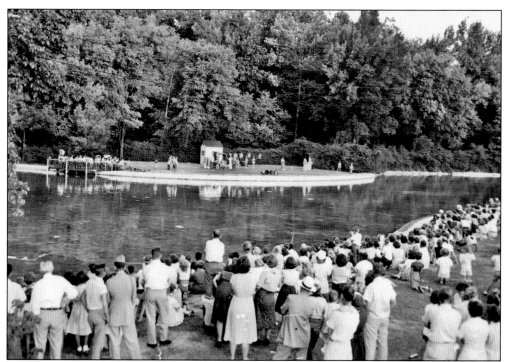

With Rainbow Lake in the foreground, scores of Memphis Park Commission youth performed plays and pageants for their parents and friends.

Shown here is the entrance to the park at the corner of Poplar Avenue and Tucker Street in the early 1950s, before the memorial statue to longtime Memphis politician E.H. "Boss" Crump was erected.

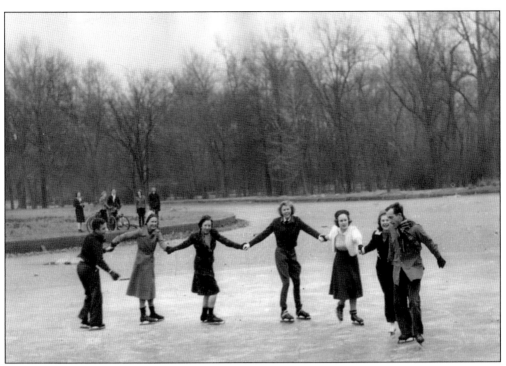

A group of ice skaters tries their luck on Rainbow Lake in 1941.

The culmination of the park commission's youth summer program was a field day celebration attended by children from all the city parks and community centers.

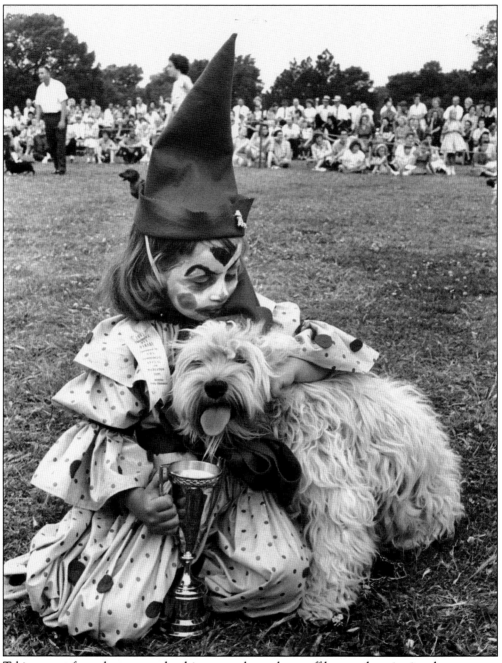

Taking a rest from the pet parade, this young clown shows off her trophy-winning dog.

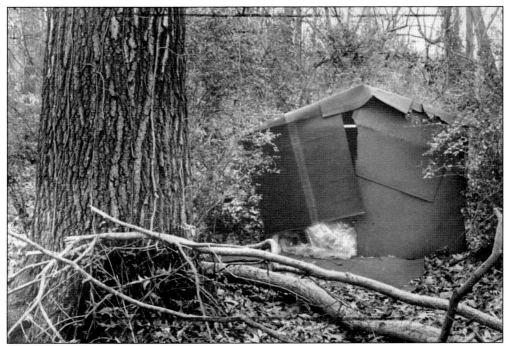

After being discovered deep in the forest by police, this tarpaper shanty was torn down. It was not, however, the first time people had lived in the park. During the Great Depression, there was an active hobo camp in the woods.

Local puppeteer Jimmy Crosthwaite rehearses in the park with local children for an upcoming pageant in the 1970s.

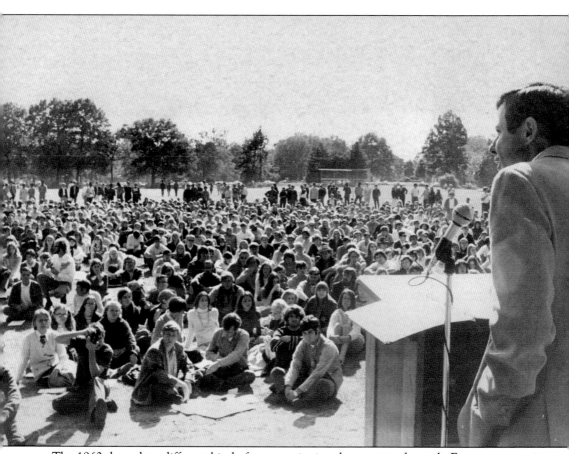

The 1960s brought a different kind of community involvement to the park. Ever a community gathering spot, the Overton Park playing field was the site for this Vietnam War protest in 1969. The speaker is former U.A. Attorney Mike Cody.

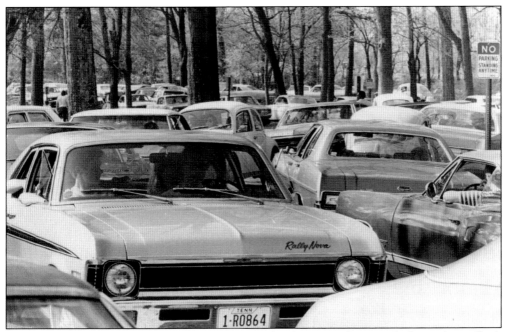

In an exercise that seemingly never goes out of style, this 1971 photograph shows the gridlock of cruising in the park. Concerts, coupled with good weather, would lure thousands, making for a frustrating day of crawling, at a snail's pace, around the many roads in the park. Later, roads through the forest would be permanently closed to vehicle traffic.

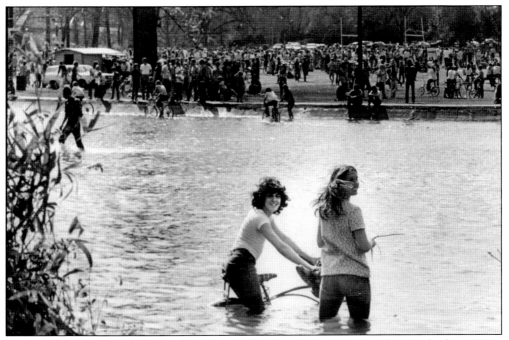

These girls, along with others, take refuge in Rainbow Lake on a hot day. By the late 1960s, neighborhood residents complained loudly to city hall about the "hippies" taking over the park on weekends.

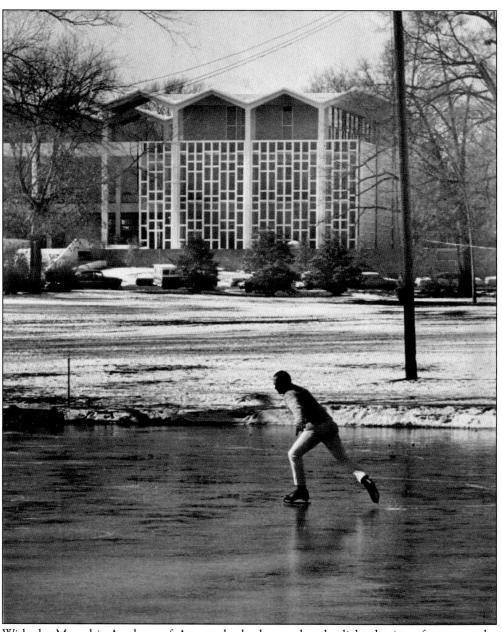

With the Memphis Academy of Art on the background and a light dusting of snow on the ground, surely the bravest man in Memphis ice skates on Rainbow Lake on February 11, 1971.

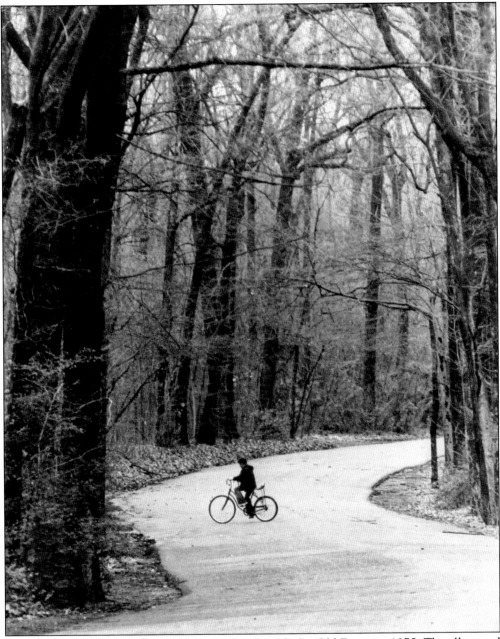

A young man pauses on his bicycle on a road through the Old Forest in 1975. The allure and importance of this old-growth forest is felt more and more as Memphians recognize its unique quality of being the only one of its kind in the world.

Prominent Memphian Robert Galloway was intrigued by the art and culture he had experienced on a trip to Japan. Upon his return, he prevailed upon park designer George Kessler to build a Japanese Garden complete with pagodas, an arched bridge, and exotic birds. It quickly became a favorite park spot, offering Memphians a taste of the Far East that would have otherwise never been experienced.

—William Bearden

Four

THE JAPANESE GARDEN

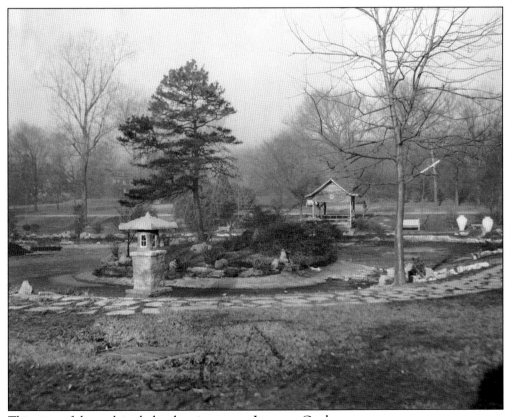

This view of the park includes the picturesque Japanese Garden.

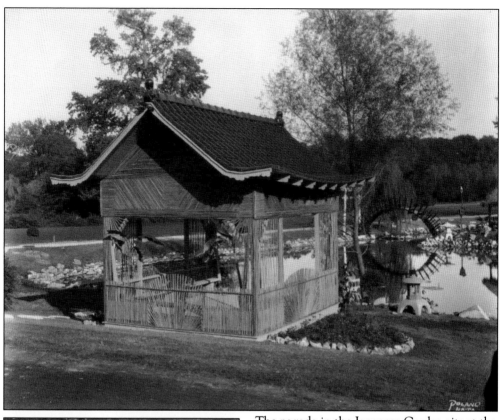

The pagoda in the Japanese Garden sits at the edge of the park's reflecting pond.

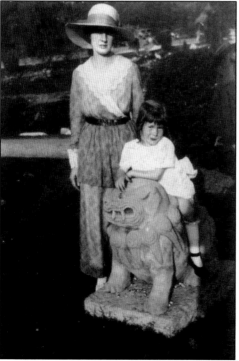

Mrs. W.W. Davidson and daughter Elizabeth pose in this c. 1918 photograph. Elizabeth is perched upon one of the few exotic sculptures found in the garden. (Courtesy of William E. Robison.)

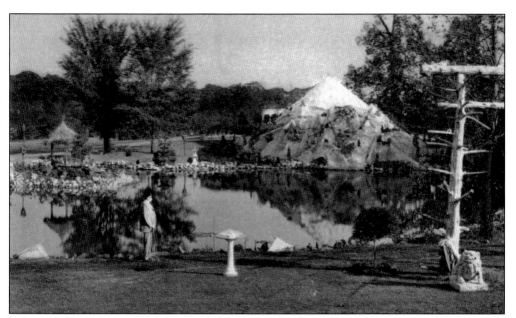

Robert Galloway's vision of sharing his Japanese voyage with the rest of Memphis emerged as a mosaic of features, including a half-moon bridge, a Shinto Torii gateway, a clutch of thatched huts, and plaster cast flamingoes at the edge of the pond. The garden was a highly photographed attraction.

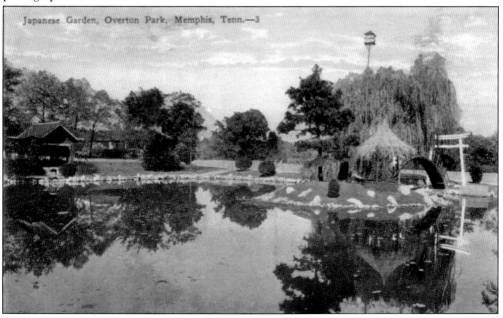

Japanese Garden, Overton Park, Memphis, Tenn.—3

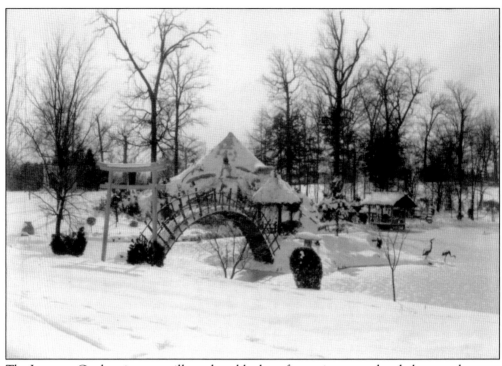

The Japanese Garden sits tranquilly under a blanket of snow in two undated photographs.

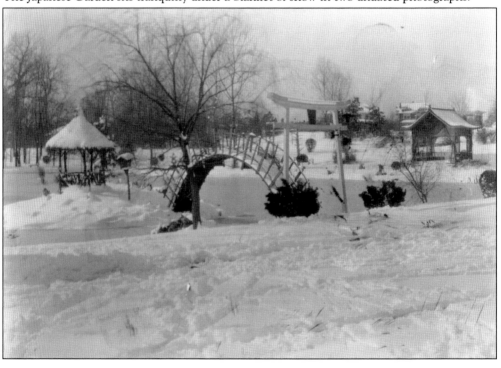

Workmen Slowly Filling Japanese Lake

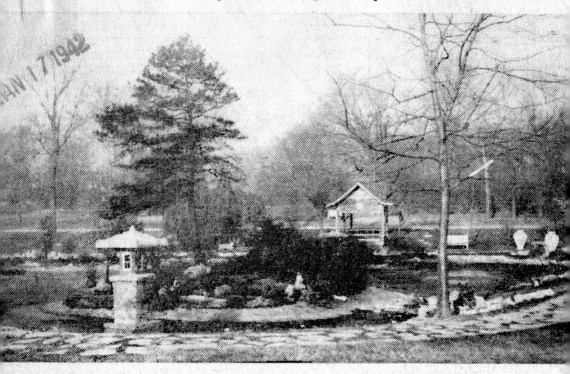

—Press-Scimitar Staff Photo

on Park's Japanese Lake was still mostly there today, but fast-moving city dump trucks gave tl
ance that not for long would his innocent bystander of war in the Pacific remain. The lake wa
illed with ice today, mute reminder of the fun which Memphians had there just last week, but i
nter of the lake, a huge island of fresh dirt is slowly spreading under the shovels of workmen, ar
xt week the lake will be gone. So far, none of the pagodas and rest houses has been torn dow

On December 8, 1941, the Japanese Garden lay in ruins, the victim of severe vandalism following the attack on Pearl Harbor. The remains of the gardens were removed and a fountain was installed in the center of the pond, both of which were removed in 1956 to make way for the parking lot of the Memphis College of Art.

*Overton Park designer George Kessler was against establishing institutions
such as the zoo, the Brooks Museum of Art and the Japanese Gardens in the park.
Park Commission member and prominent Midtown resident Robert Galloway argued
that the park needed these social and cultural amenities.
Galloway won the argument.*
—John Linn Hopkins

Five

THE BROOKS MUSEUM *of* ART

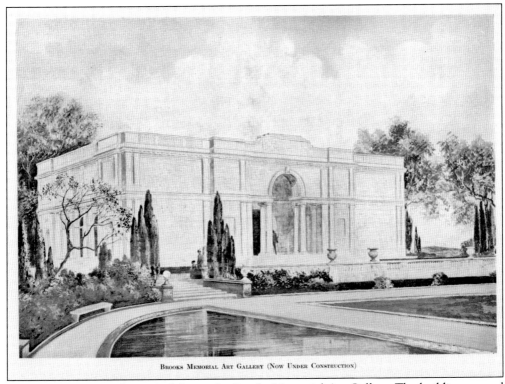

BROOKS MEMORIAL ART GALLERY (NOW UNDER CONSTRUCTION)

An artist's rendering from 1915 shows the Brooks Memorial Art Gallery. The building opened to the public on May 26, 1916.

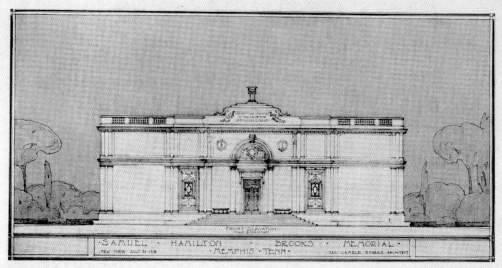

Designed by James Gamble Rogers, architect of the Shelby County Courthouse and of the Gothic Revival campus buildings at Yale and Princeton, the Italian Renaissance façade of the Memphis Brooks Museum of Art truly deserves its nickname as the "jewel box" of Overton Park.

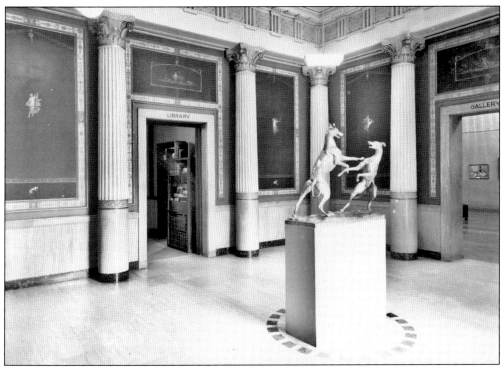

The completed museum building was dedicated on May 26, 1916. The ceremony was quite a spectacle, as it celebrated the Brooks family 40-year effort to establish "a visible credential" of Memphis's appreciation of the arts.

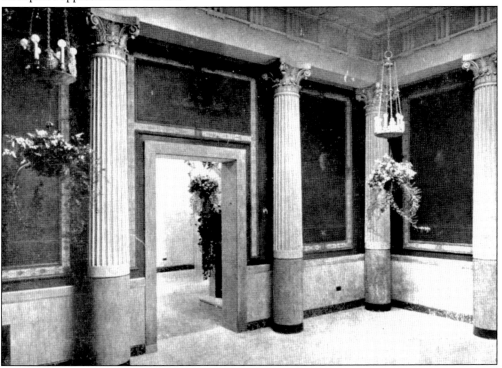

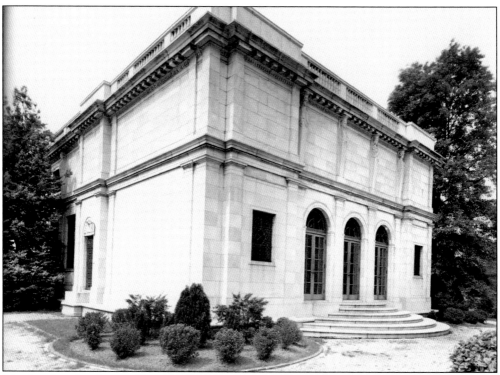

The first few decades would prove slow in acquiring quality pieces of art for the Brooks family's permanent collection. The museum mostly served as a showplace for exhibits of the works of local artists and traveling exhibits that were provided through the Southern States Art League and the American Federation of Arts.

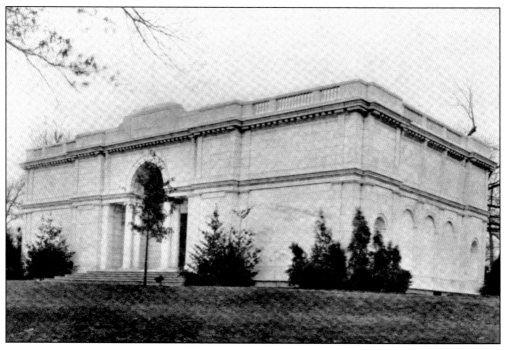

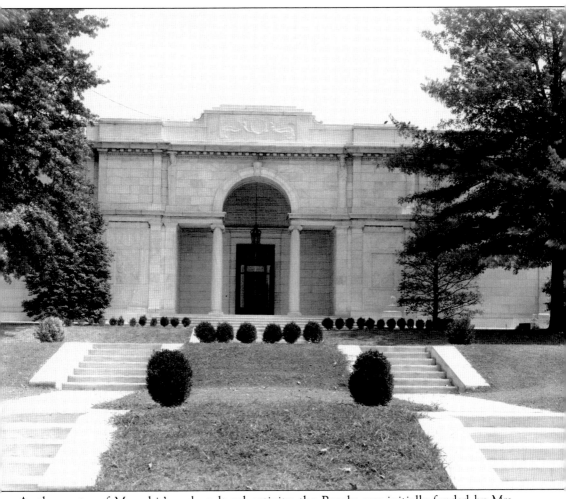

As the center of Memphis's early cultural activity, the Brooks was initially funded by Mrs. Samuel H. Brooks, in memory of her husband.

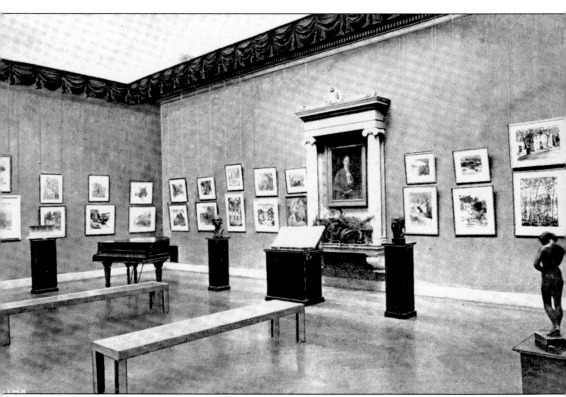

In 1943, the McCall Collection and the Doughty Bird Collection were donated to the Brooks, marking the first major contributions to the museum's permanent collection since opening in 1916. The Doughty Bird Collection was completed in 1959.

The Kress Foundation made a significant donation to the Brooks permanent collection in 1958, not long after the first addition to the museum in 1955. The donation included 28 Renaissance paintings and 2 sculptures, giving the Brooks a degree of credibility and prestige that it had not previously enjoyed.

Since the museum's opening, the building has undergone four separate additions, the most recent in 1990, to accommodate the museum's ever-expanding needs and the public's ever-growing interest in the visual and decorative arts. Through all its changes, however, the unique, timeless characteristics that defined the Brooks in 1916 still exist today. (Photo below courtesy of William E. Robison.)

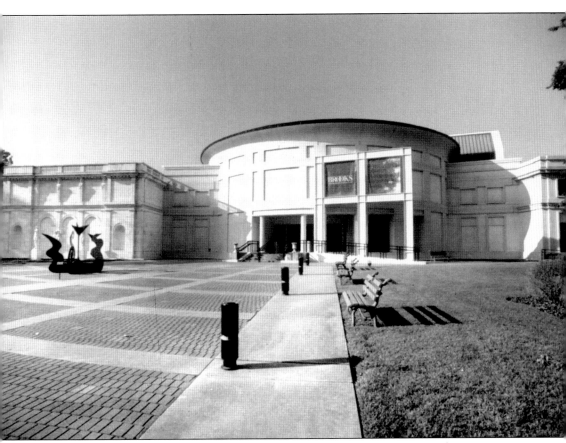

In the last quarter-century, the Memphis Brooks of Art has grown in reputation and visitation at an admirable pace. Today, the museum continues an aggressive program to further its standing as a major facility for art appreciation and education. (Courtesy of William Bearden.)

Keeping watch over the Tucker Street entrance to Overton Park is the commanding figure of Edward Hull Crump. "Boss" Crump was a driving force in city and statewide politics for over half a century. He was a Memphis businessman, managing a carriage manufacturing firm at the turn of the 20th century, rising to political power steadily after his entrance into politics as a city councilman in 1905. A brief four years later saw him elected as the mayor of Memphis, an office he held until 1919. Although he never returned to an official elected position, Crump's local political influence was all encompassing until his death on October 16, 1954. This statue is the only memorial to a political leader in the city and was unveiled on April 21, 1957.
—Savannah Bearden

Six

THE MONUMENTS

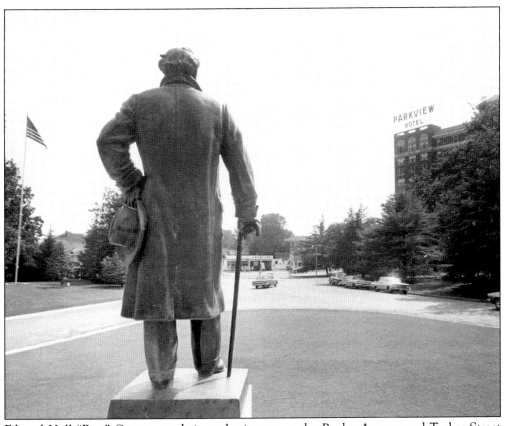

Edward Hull "Boss" Crump stands in a classic pose at the Poplar Avenue and Tucker Street entrance to the park.

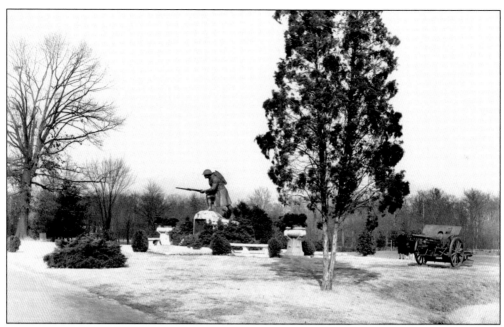

One of the most recognizable symbols of Overton Park, the Doughboy Memorial sits at the west end of the playing fields. Sculpted by Nancy Coonsman Hahn and dedicated in 1926 to the memory of those Shelby County citizens who served in World War I, the Doughboy stands as the outward, public expression that states, "We honor what you did for us. We will remember."

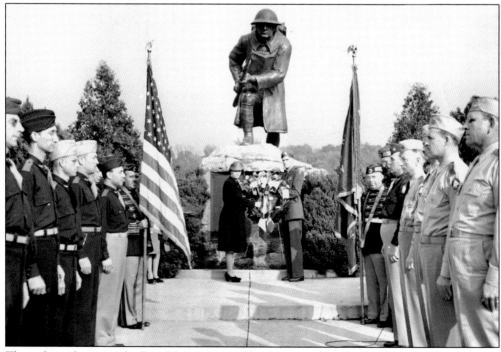

Throughout the years, the Doughboy Memorial has become a key site for Memorial Day services. Here, the holiday is observed in 1942, when the Allies were facing dark days in Europe and the Pacific. Memphis took time to remember.

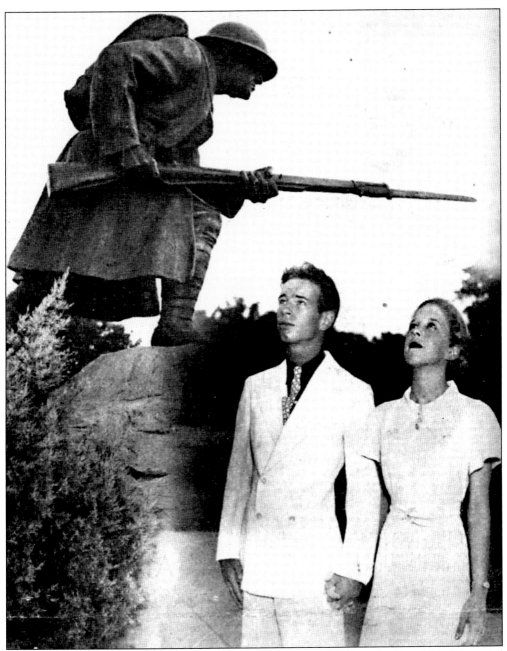

Despite being modeled after an American World War I trench soldier, the Doughboy Memorial pays tribute to all who have served and lost their lives for their country. A young couple holds hands at the base of the Doughboy in 1941, seemingly in a show of solidarity during the trying times of the Second World War.

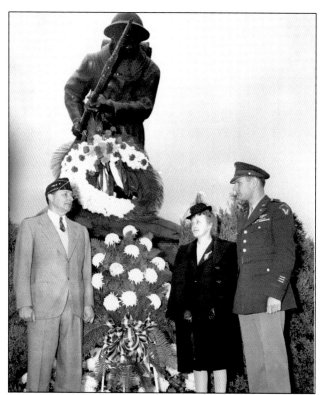

A memorial service in 1945 joins both veterans and active service members in reverence for those who came before and offered the ultimate sacrifice for freedom.

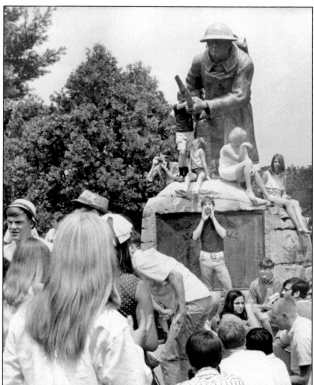

Ever a community gathering spot, these students met at the Doughboy Memorial for a Vietnam protest in 1967.

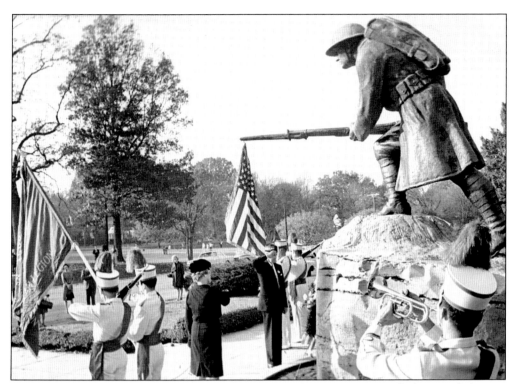

Two separate Memorial Day ceremonies—the one above in 1964 and the one below in 1970—show that the Doughboy Memorial is a source of constancy and ritual amidst the ever-changing park landscape.

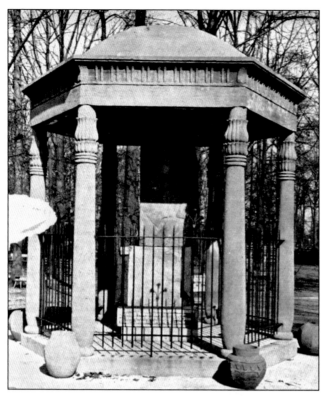

Donated by Robert Galloway, the Egyptian Temple was built to house the gate stones from the Temple of Ptah, in Memphis, Egypt. The stones are now housed at the University of Memphis Gallery as part of their permanent collection of Egyptian artifacts.

An original member of the Memphis Park Commission, Judge L.B. McFarland was memorialized in 1930 by a granite bell tower that stands just south of the Memphis College of Art.

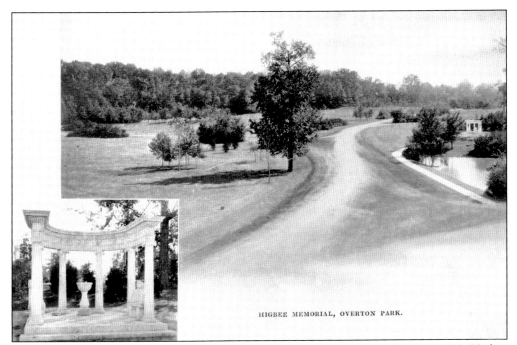

HIGBEE MEMORIAL, OVERTON PARK.

Taking honors as the oldest existing monument in Overton Park is the Jenny M. Higbee Memorial Peristyle. Higbee was the first woman to be selected as principal of a Memphis high school, and she established The Higbee School in 1878, which was considered one of the finest Southern preparatory schools of the time. She continued her career as a distinguished local educator until her death in 1906.

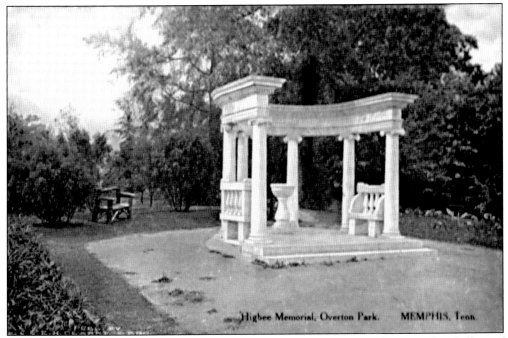

Higbee Memorial, Overton Park. MEMPHIS, Tenn.

The Higbee Memorial was originally located on the site of the present-day Memphis College of Arts. However, it was moved to the northeast side of the formal gardens around 1956.

89

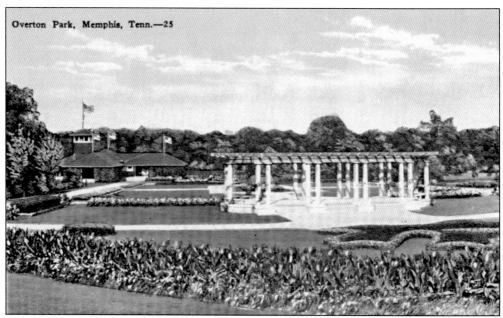

The Clara Conway Memorial Pergola was part of the original three elements of Overton Park, the other two being the pavilion and the formal gardens. The pergola was a tribute to Clara Conway who, among other accomplishments, integrated the first kindergarten program into her Memphis school, the Clara Conway Institute for Girls. The institute received national acclaim for its excellence in education. The Clara Conway Alumnae Association donated the Conway Memorial after her death in 1904. Unfortunately, the structure was destroyed in a 1936 storm.

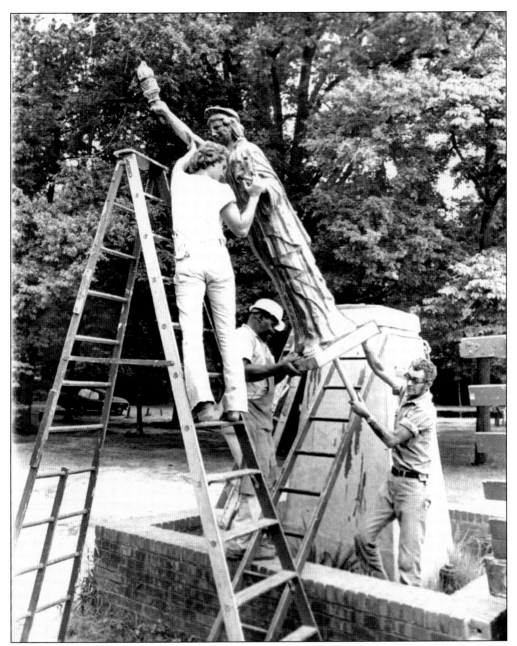

An oft forgotten monument in the park, this eight-foot replica of the Statue of Liberty was located north of the playing fields in 1950. The statue was donated to the city by Arthur Bruce, the founder of a local hardwood flooring company. The replica was removed in 1975 as a result of vandalism, but the pedestal still stands to this day.

The Overton Park Shell structure was completed by the Memphis Works Progress Administration (WPA) in 1936 by Max Furbringer, architect. It was patterned after the larger ampitheaters in Chicago, New York, and St. Louis. A 65-piece orchestra was composed of local professional musicians from the Memphis Federation of Musicians, and the WPA band performed for the dedication on September 13, 1936, before a 6,000-member audience.

—Roy Brewer

Seven

THE SHELL

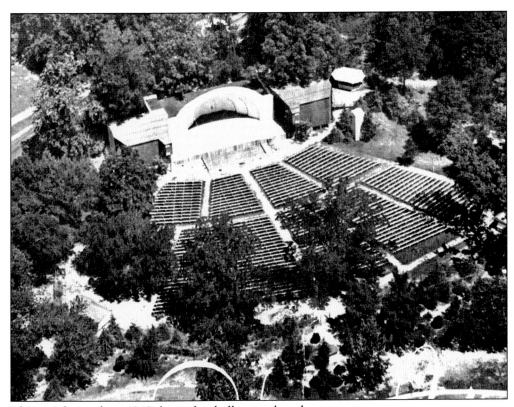

This aerial view from 1948 shows the shell in its glory days.

A cast-iron bandstand once stood on the present-day site of the Memphis Brooks Museum of Art. From 1904 to its demolition in 1926, the bandstand was the only formal site for outdoor performances in Overton Park.

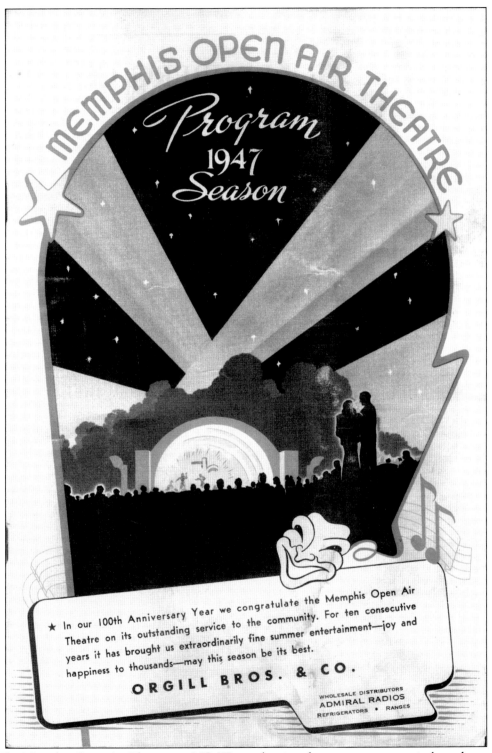

The Memphis Open Air Theatre, or MOAT, was the site of many concerts, musicals, and stage plays during the 1930s, 1940s, and 1950s. (Courtesy of Save Our Shell, Inc.)

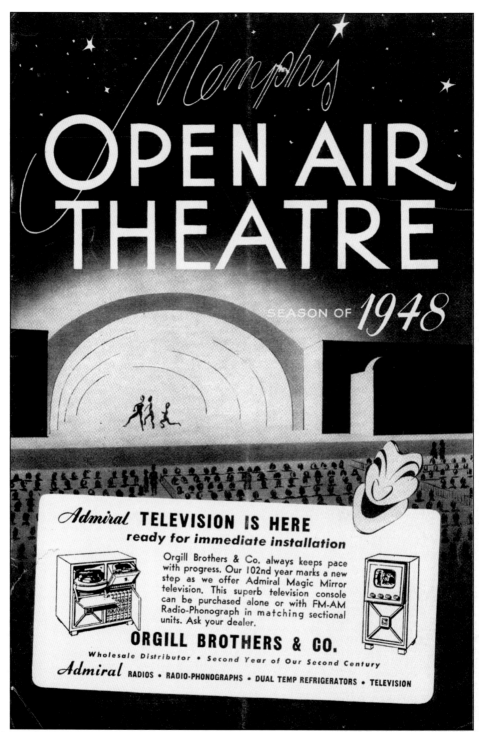

Shown here is a program cover from Memphis Open Air Theatre's 1948 season. MOAT was a staple in Memphian entertainment, especially during the hot summer months. (Courtesy of Save Our Shell, Inc.)

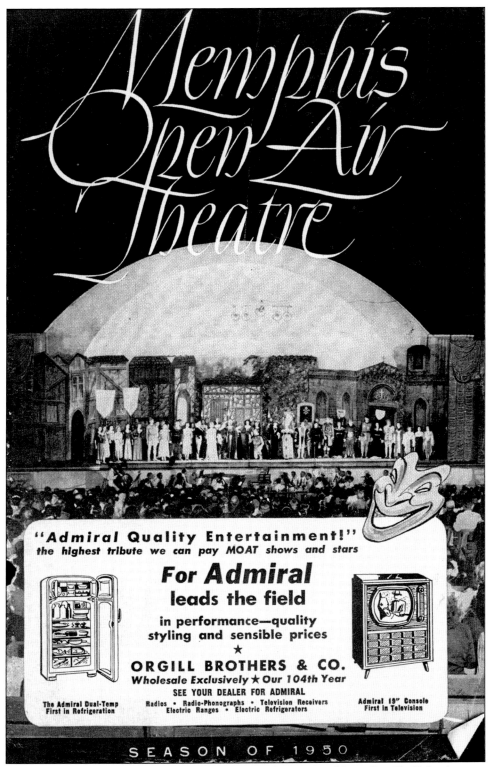

This program cover was from MOAT's 1950 season. (Courtesy of Save Our Shell, Inc.)

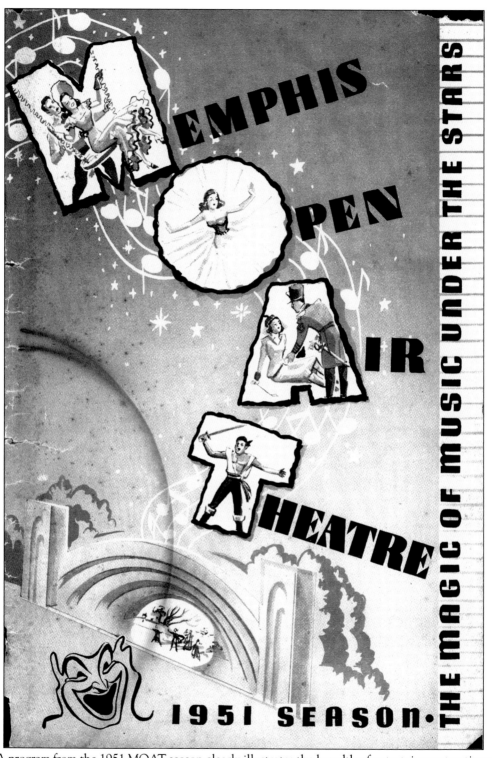

A program from the 1951 MOAT season clearly illustrates the breadth of entertainment options that the shell had to offer in its heyday. (Courtesy of Save Our Shell, Inc.)

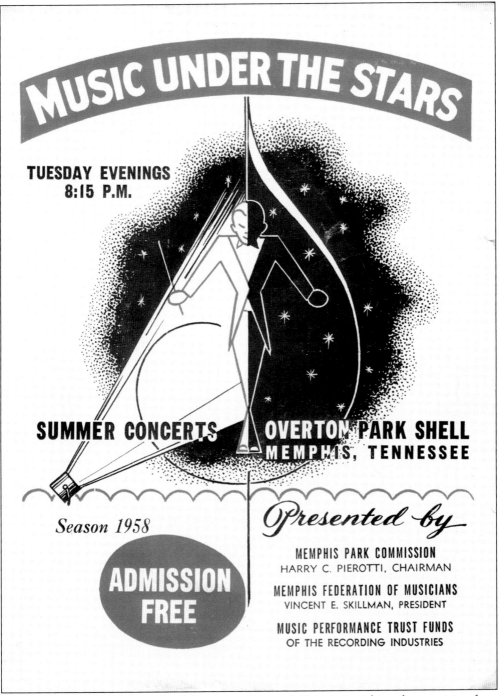

MUSIC UNDER THE STARS

TUESDAY EVENINGS
8:15 P.M.

SUMMER CONCERTS OVERTON PARK SHELL
MEMPHIS, TENNESSEE

Season 1958

ADMISSION FREE

Presented by

MEMPHIS PARK COMMISSION
HARRY C. PIEROTTI, CHAIRMAN

MEMPHIS FEDERATION OF MUSICIANS
VINCENT E. SKILLMAN, PRESIDENT

MUSIC PERFORMANCE TRUST FUNDS
OF THE RECORDING INDUSTRIES

On this program cover from the 1958 season, the amphitheater is making the transition from the Memphis Open Air Theatre to the Overton Park Shell. (Courtesy of Save Our Shell, Inc.)

99

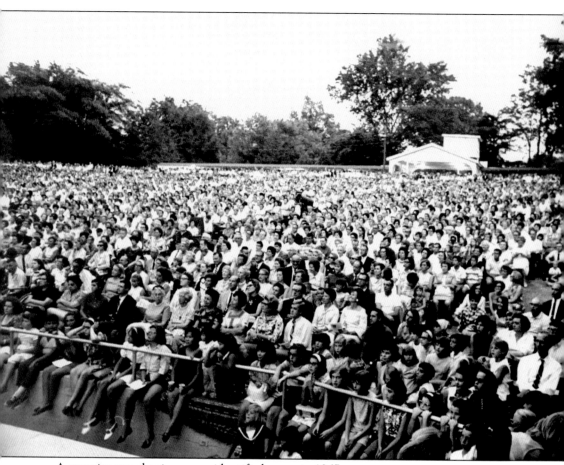

A capacity crowd enjoys an unidentified event in 1967.

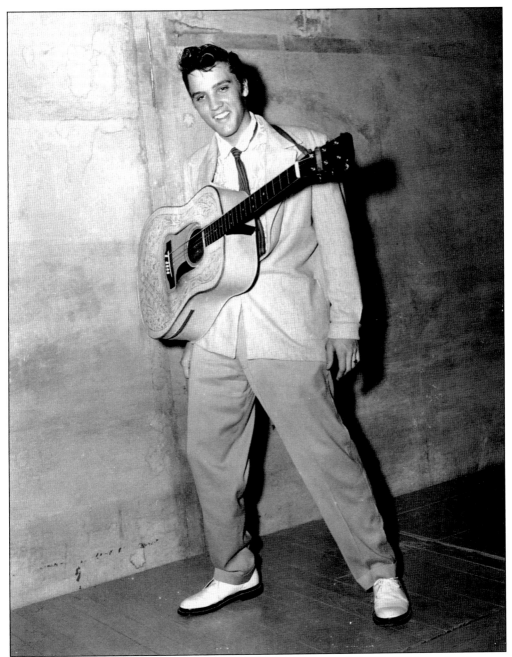

Elvis Presley's first paid performance on a major stage was on July 30, 1954, at the Overton Park Shell. He opened for Slim Whitman and Billy Walker. About two weeks later he appeared at the shell again, this time opening for country music star Webb Pierce. After a particularly rousing performance by Elvis for the hometown crowd, Pierce was reported to have said, "Wow, how come I gotta follow him?" (Courtesy of Save Our Shell, Inc.)

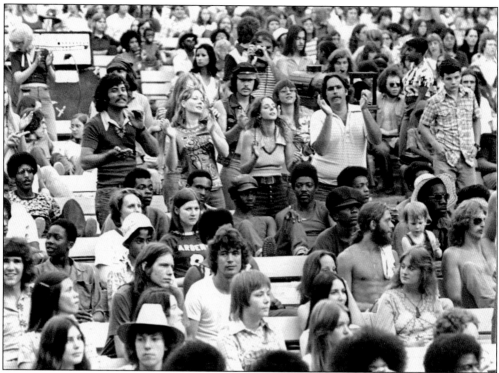

In 1974, the Memphis Park Commission determined that the shell should be a free venue. The last ticketed concert was by pop duo Seals and Croft and drew an astounding 23,000 people. The fences, which were scheduled to be removed the next day, came down during the concert

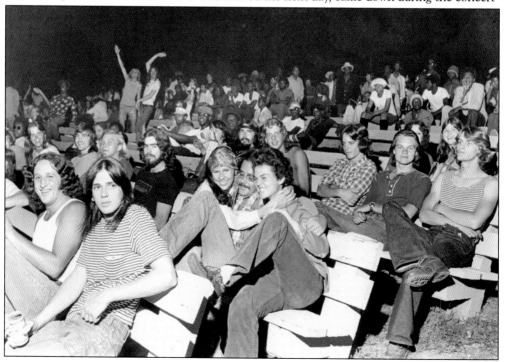

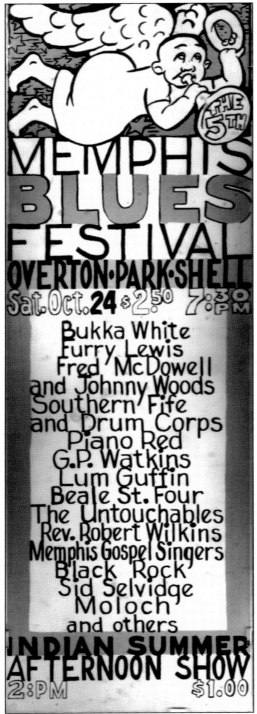

An impressive line-up of locally and nationally known artists is shown on this poster for the Memphis Blues Festival from the late 1960s. This festival was the forerunner of what has now become the massive Memphis in May Blues Festival, held annually in downtown Memphis. (Courtesy of Save Our Shell, Inc.)

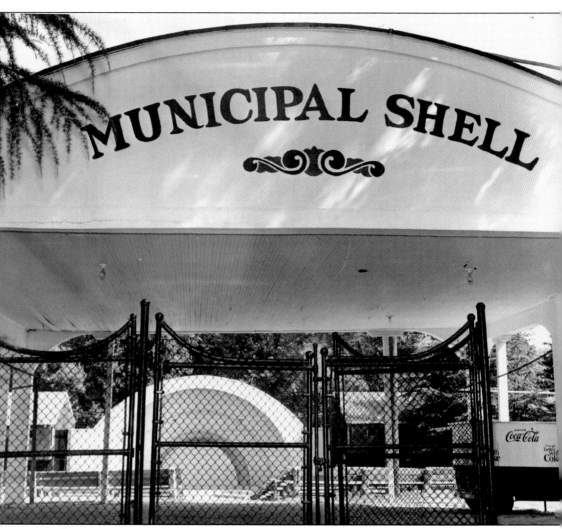

This image shows the entrance to the Overton Park Municipal Shell before the gates were removed.

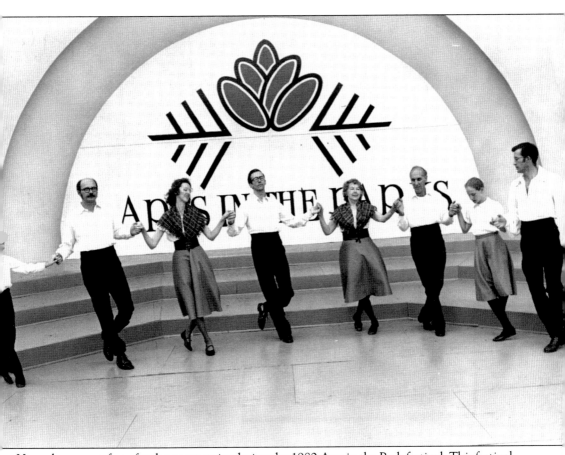

Here, dancers perform for the community during the 1980 Arts in the Park festival. This festival was held in Overton for two years and then moved to Audubon Park in East Memphis.

A common thread weaves tenaciously throughout the mission of Memphis College of Art: dedication to excellence in art and design education and commitment to making visual arts education widely accessible.
—Jeffrey D. Nesih

Eight
MEMPHIS COLLEGE
of ART

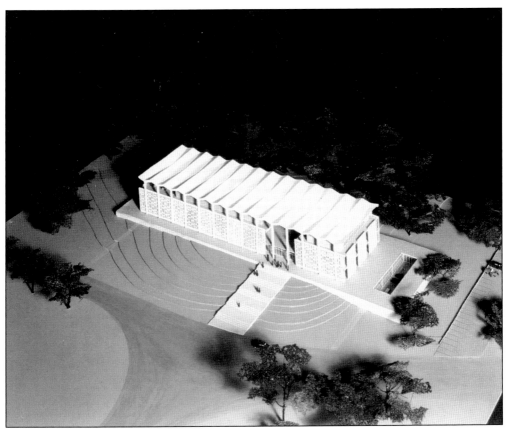

This 1958 model shows the initial design of Memphis College of Art (MCA).

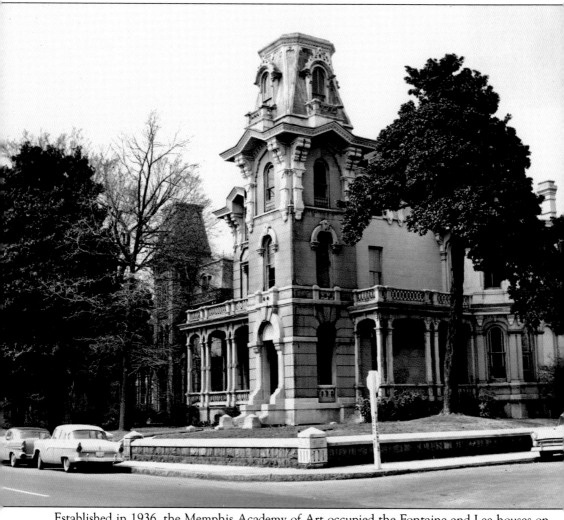

Established in 1936, the Memphis Academy of Art occupied the Fontaine and Lee houses on Adams Avenue in what is known today as Victorian Village.

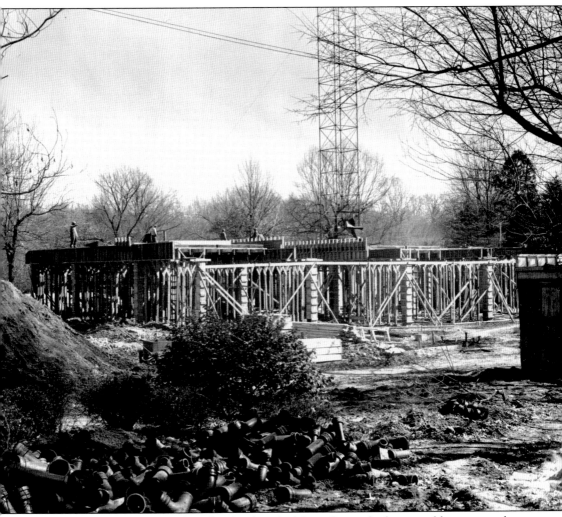

By the 1950s, it was apparent that the Academy's Adams Street facilities could not properly accommodate the school's 50 full-time and 130 part-time students. At the urging of then-mayor Frank Tobey to move the academy closer to the city's other higher learning institutions, a site was selected in Overton Park and construction began in carefully planned-out phases. The first portion opened in February 1959.

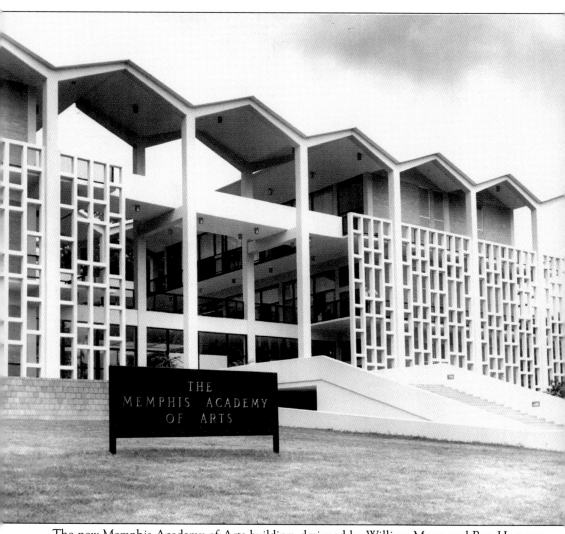

The new Memphis Academy of Arts building, designed by William Mann and Roy Harrover, was built at a cost of $500,000. The building provided the impetus for the aggressive expansion of the academy's curriculum, resulting in the accreditation by the Southern Association of Schools of Arts and Design in 1961.

With the new growth, the academy was now able to attract impressive talent for its faculty, including regional and nationally recognized artists.

Enrollment in the academy doubled between 1961 and 1967, forcing the need for a second addition. The design team of Mann and Harrover collaborated again to carry out this second phase in 1967 at a cost of $800,000. In 1975, the enrollment had swelled to 240 full-time and 340 part-time students, sparking the requirement of a third and final addition.

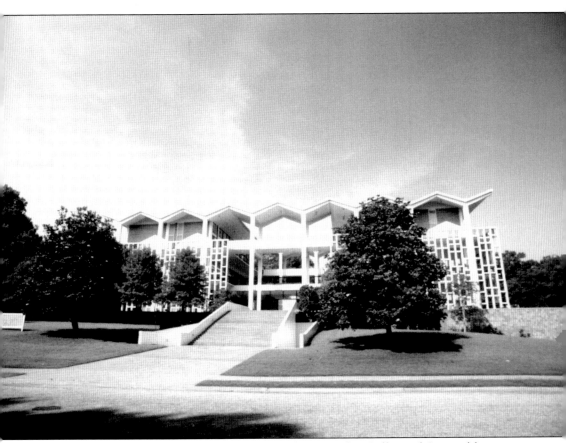

Now in its second half-century with a new name, The Memphis College of Art, and having gained a solid footing in the academic and cultural institutions of the South, the college continues to vigorously expand its programs for the Mid-South and beyond. (Courtesy of William Bearden.)

The Evergreen neighborhood began as the gateway to Overton Park, and the two entities have since shared a strong connection. It was the effort of the people acting on behalf of the park that saved the neighborhood from permanent destruction when the Supreme Court ruled I-40 could not proceed—but only after hundreds of homes were needlessly torn down. Today, as I walk through the neighborhood I see new homes that have been thoughtfully constructed amongst the old, and I cannot help but think that like a broken bone healed, Evergreen is a stronger neighborhood for it.

Without Overton park, Evergreen as we know it would not exist.

—Bill Bullock

Nine

THE OLD FOREST *and* SIDEWALKS *to* NOWHERE

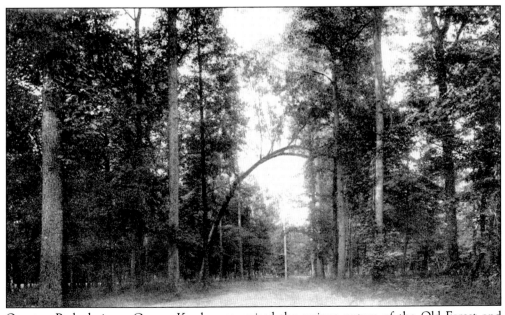

Overton Park designer George Kessler recognized the unique nature of the Old Forest and sought to leave it in its pristine state.

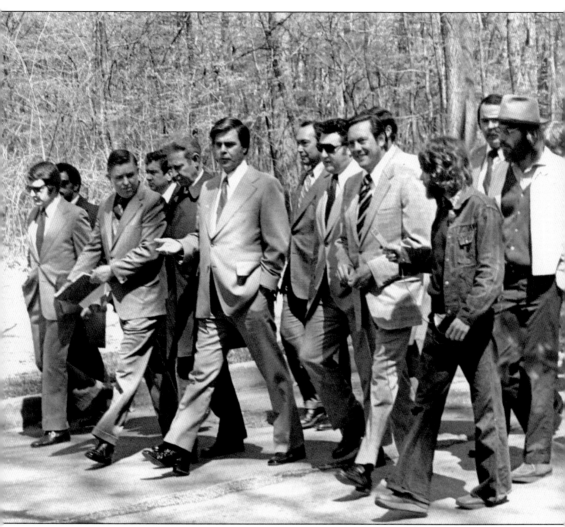

Overton Park activists confront Memphis mayor Wyeth Chandler and Tennessee senator Bill Brock in one of many "fact finding" missions politicians made to the park. At issue was the routing of Interstate 40 through the middle of the park. The controversy spanned the administrations of four Memphis mayors and as many national administrations. The name of Overton Park is known across the country as the subject of a precedent-setting law case, *Citizens to Preserve Overton Park, Inc. (CPOP) v. Volpe*. The suit challenged Secretary of Transportation John Volpe's initial approval of a Tennessee Department of Transportation plan for construction of Interstate 40 through the park.

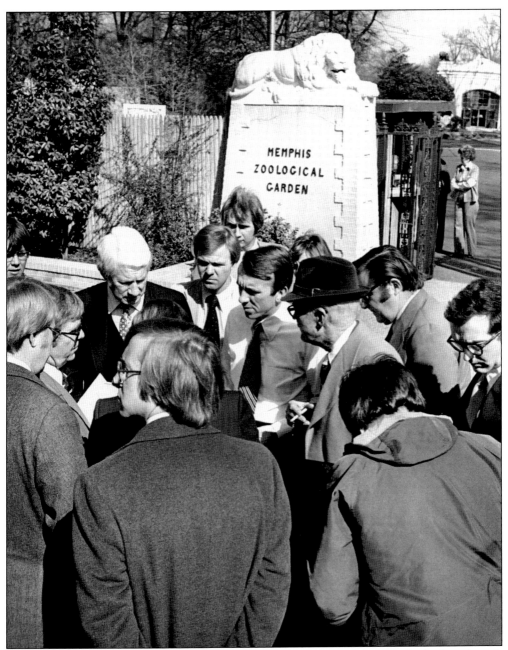

It seemed that every month or so a new group would present a plan for the highway's path through the park. Members of Citizens to Preserve Overton Park mounted a heroic effort against enormous odds to stop the project. In the end, the neighborhood won. In 1971, the U.S. Supreme Court ruled in favor of CPOP, stating that "applicable laws prohibited the authorization of federal funds for construction of highways through public parks, unless it could be demonstrated that no 'feasible and prudent' alternative route existed." This decision has been hailed by those who view parks as amenities that make our cities livable.

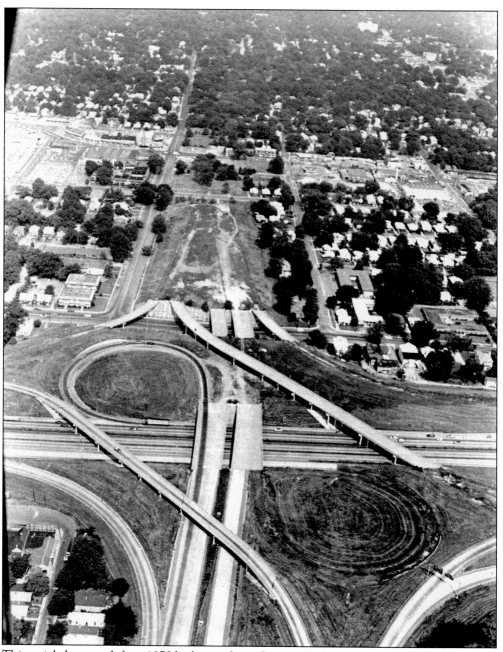

This aerial photograph from 1970 looks east down Overton Park Avenue. In 2004, the Tennessee Department of Transportation began work to make the exit from Interstate 40 to Interstate 240 a permanent structure.

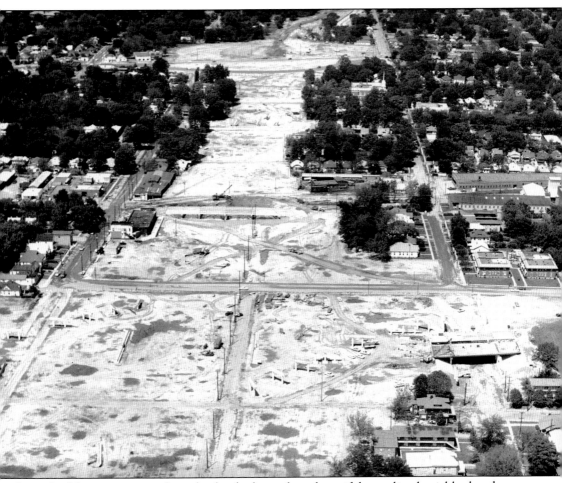

A swath of devastation cuts through what had once been beautiful, tree-lined neighborhoods.

By 1970, the Evergreen community, just west of Overton Park, had lost 408 single family homes, 84 duplexes, 266 apartments, 44 businesses, 5 churches, and a fire station.

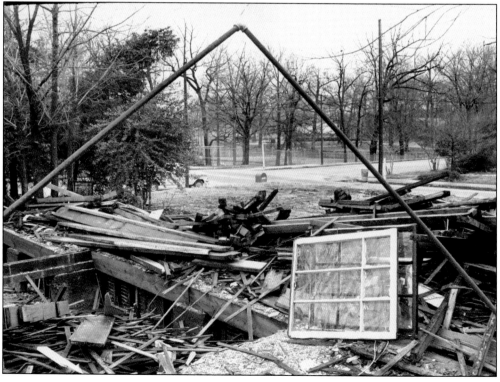

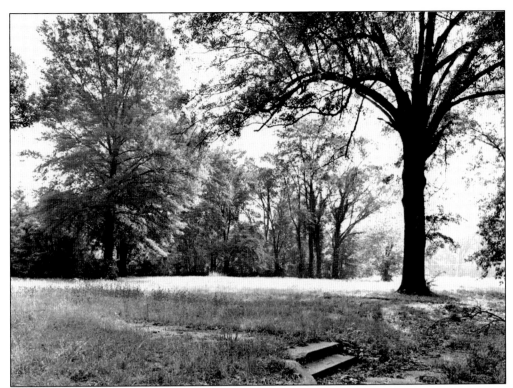

One of the saddest sights was in the spring when the dogwoods were blooming and tulips were pushing out of the ground in empty lots. These "sidewalks to nowhere" outlined the haunted spaces of block after block of demolished houses.

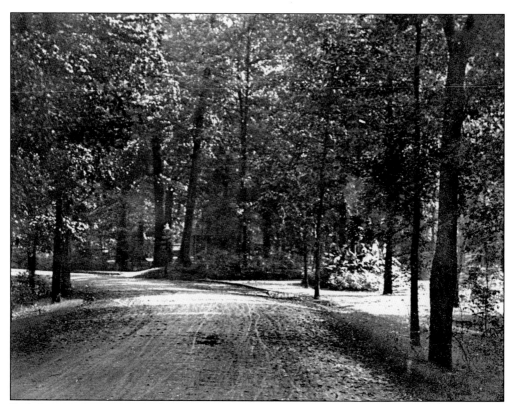

Park designer George Kessler laid out the roads in circuitous routes, giving the feeling of isolation even though the hustle and bustle of the city was near.

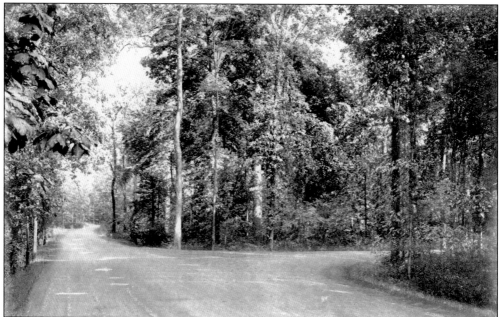

Today, the Old Forest looks much as it did in the early part of the 20th century. Changes to the park have not left their mark on the forest.

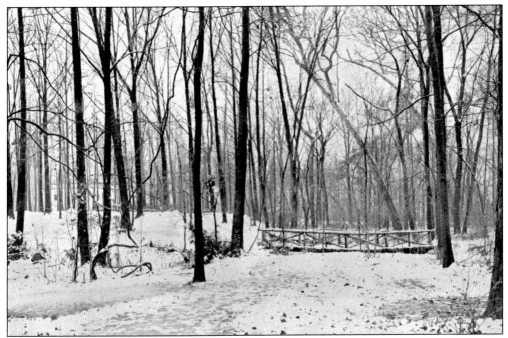

At Christmas in 1914, a dusting of snow covers the forest in Overton Park.

This entrance to the forest is located next to the parking lot for the playground. The roads have been off-limits for vehicle traffic since 1994. The citizens group, Park Friends, Inc., has taken on an advocacy role for the park since 1996. At the urging of the group in 2003, the Memphis City Council ruled to close the park during nighttime hours.

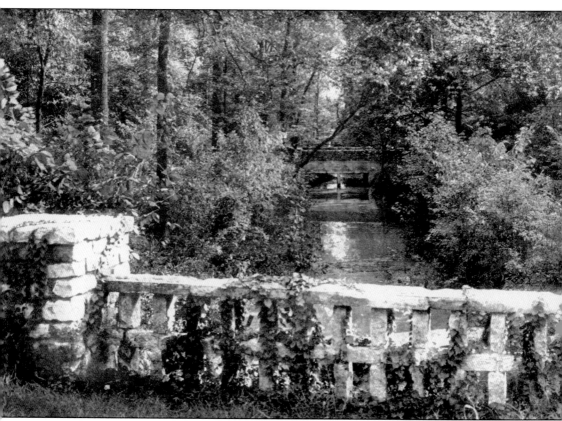

The stone bridges are one of the most identifiable features of the park. Lick Creek runs from north to south through the heart of the forest. As the city has grown and lifestyles have changed, Overton Park has remained the place where Memphians and tourists alike come for relaxation and inspiration. A dream in the minds of visionaries has become in reality a place of enduring value for the entire community.

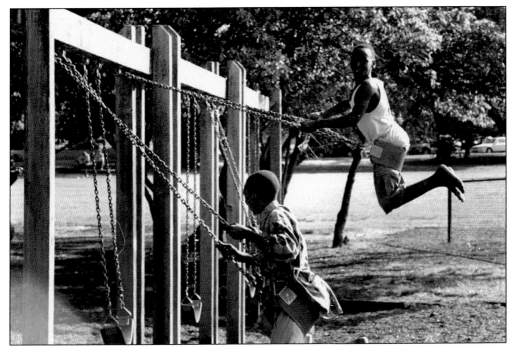

Today the park stands as a true reflection of the people of Memphis. Its first 100 years have seen both good and bad times, but the park remains a special place in the hearts of all Memphians. (Courtesy of Hal Harmon.)

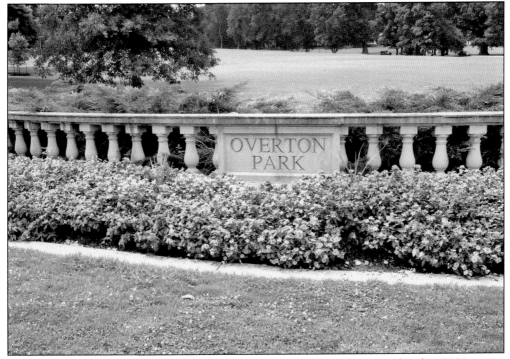

This entrance to the park on Poplar Avenue near Cooper Street was completed in 2001 as part of the ongoing improvements to Overton Park. (Courtesy of William Bearden.)

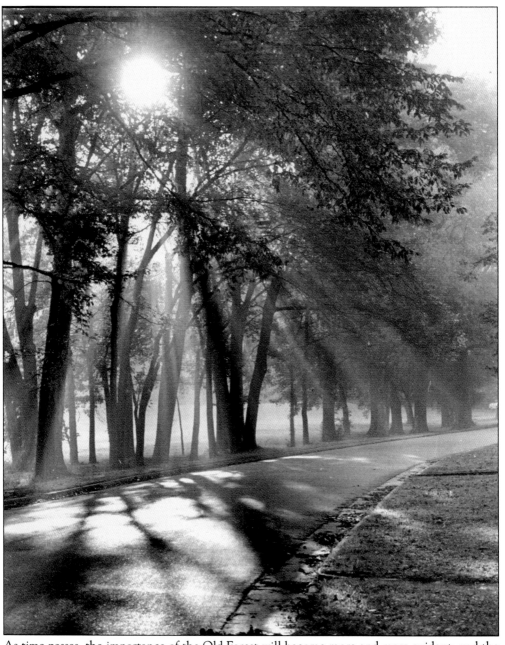

As time passes, the importance of the Old Forest will become more and more evident, and the vision of our forebears will become even more profound.

CHRONOLOGY

1819 Founding of Memphis. Judge Overton's town plan includes four park squares and a river promenade.

1858–1863 Frederick Law Olmsted Sr. and Calvert Vaux first work at Central Park in New York City.

1882 George E. Kessler returns from landscape studies in Europe, corresponds with F.L. Olmsted Sr., and moves to Kansas City.

1889 Judge L.B. McFarland begins a crusade for a public park system in Memphis.

1890 Kansas City adopts Kessler's plans for a park and parkway system.

1898 A representative of Olmsted's firm, likely John C., visits Memphis to investigate potential a park system.

1898 J.J. Williams is elected mayor; his platform included goals of Greater Memphis Movement.

1899 Tennessee state legislature authorizes the establishment of Memphis Park Commission.

1900 City establishes Memphis Park Commission, with Judge J.B. McFarland as chairman and Robert Galloway and John Godwin as commissioners.

1901 City acquires Lea Woods from Overton Lea. The area is renamed Overton Park. Memphis Park Commission requests proposals for a system of "parks, drives, and boulevards." Olmsted Brothers and Kessler respond. Kessler is selected.

1902 Riverside Park is acquired.

1902–1904 The main pavilion at the west end, the picnic pavilion at the east end, and the lake ("Rainbow") are constructed in Overton Park.

1904 Louisiana Purchase Exposition (St. Louis World's Fair) takes place. George E. Kessler is the chief landscape architect.

1904 Clara Conway Memorial Arbor is constructed in a formal garden in Overton Park. It is later demolished by a storm in 1936.

1905 U.S. Supreme Court ruling in *Memphis v. Hastings* clears the way for the development of parkways.

1906 Overton Park golf course is established as the first public golf course in the region.

1906 Memphis Zoo is established,

1908 Jenny M. Higbee Memorial is built near the later site of Brooks Museum. It is moved near the formal garden c. 1959.

1911 Overton Park playground is developed and is the first of its kind in Memphis.

1914 Japanese Garden is located around the lake at the present site of Memphis College of Art. It was a gift of Robert Galloway and was destroyed in 1941.

1914 Duke Bowers wading pool at Overton Park playground opens. It closed c. 1979.

1916 Brooks Art Gallery is constructed by James Gamble Rogers, architect.

1917 The Egyptian temple is built near the zoo entrance to house the gate stone from the Temple of Ptah. The stone is now at the University of Memphis.

1917 The Pavilion built and dedicated to park commissioner Willingham built near Brooks, adjacent to golf course.

1926 Overton golf clubhouse, a gift of Abe Goodman, park commissioner, is constructed. E.L. Harrison is the architect.

1926 Doughboy memorial statue, sculpted by Nancy Coonsman Hahn, is unveiled in Overton Park.

1930 The Bell Tower, which honors park commissioner McFarland, is built near the present site of Memphis College of Art. Hanker and Cairns are the architects.

1936 Overton Park Shell is built by WPA. Max Furbringer and Merrill Ehrman are the architects

1936 Memphis Street Railway waiting shelters are constructed at the zoo entrance.

1955 Overton Park entrance "gates" are erected at Tucker Street and Poplar Avenue.

1957 The memorial to Mayor E.H. Crump is dedicated. Donald Harcourt Delue is the sculptor.

1959 Memphis Academy of Arts moves to Overton Park from Victorian Village. William Mann and Roy Harrover are the architects.

1959 Memphis Aquarium, a gift of Abe Plough, is established as part of the zoo.

1960s Black citizens afforded unrestricted access to Overton and other Memphis parks.

1960s–1970s These were the principal years of dispute over I-40 route.

1971 U.S. Supreme Court ruling in favor of Citizens to Preserve Overton Park halts construction of the interstate through Overton Park.

1973 The second addition to Memphis Brooks Museum of Art opens. Walk Jones and Francis Mah are the architects.

1979 Overton Park Historic District is entered in the National Register of Historic Places.

1985 Memphis Academy of Arts name changes its name to Memphis College of Art.

1986 Memphis Zoo and Aquarium Master Plan drawn up by Design Consortium, zoo planners.

1987 Memphis Brooks Museum of Art expansion is designed. Skidmore, Ownings and Merrill with Askew, Nixon, Ferguson and Wolfe are the architects. Construction is completed in 1990.

1988 Overton Park Master Plan is approved by Memphis Park Commission. Ritchie Smith Associates are the landscape architects.

1994 Roads are closed to vehicle traffic through the Old Forest.

2000 Old Forest Trail established.

2001 *Overton Park, A Century of Change*, a documentary film, explores the first 100 years of Overton Park.

2002 The Old Forest Arboretum becomes certified by the State of Tennessee and the Tennessee Urban Forestry Council.

2003 Pandas arrive at zoo on loan from China.

2004 Memphis City Council votes to close park during nighttime hours.